A History of
GOLF IN GEORGIA

JOHN COMPANIOTTE

THE
History
PRESS

Published by The History Press
Charleston, SC
www.historypress.net

Copyright © 2016 by John Companiotte
All rights reserved

Front cover, background: Country Club of Columbus. *Russell Kirk*; *top row*: Bobby Jones, Charlie Yates and Louise Suggs;
bottom: 2009 USGA Women's State Team Champions from Georgia: Captain Sissi Gann, Laura Coble, Mariah Stackhouse and Dori Carter.
Inside flap: Jekyll Island Club about 1920. *Jekyll Island Museum archives.*
Back flap: Brunswick Country Club about 1910. *Dick McDonough.*

First published 2016

Manufactured in the United States

ISBN 978.1.46711.790.6

Library of Congress Control Number: 2015954743

For Emma Lewis Companiotte

CONTENTS

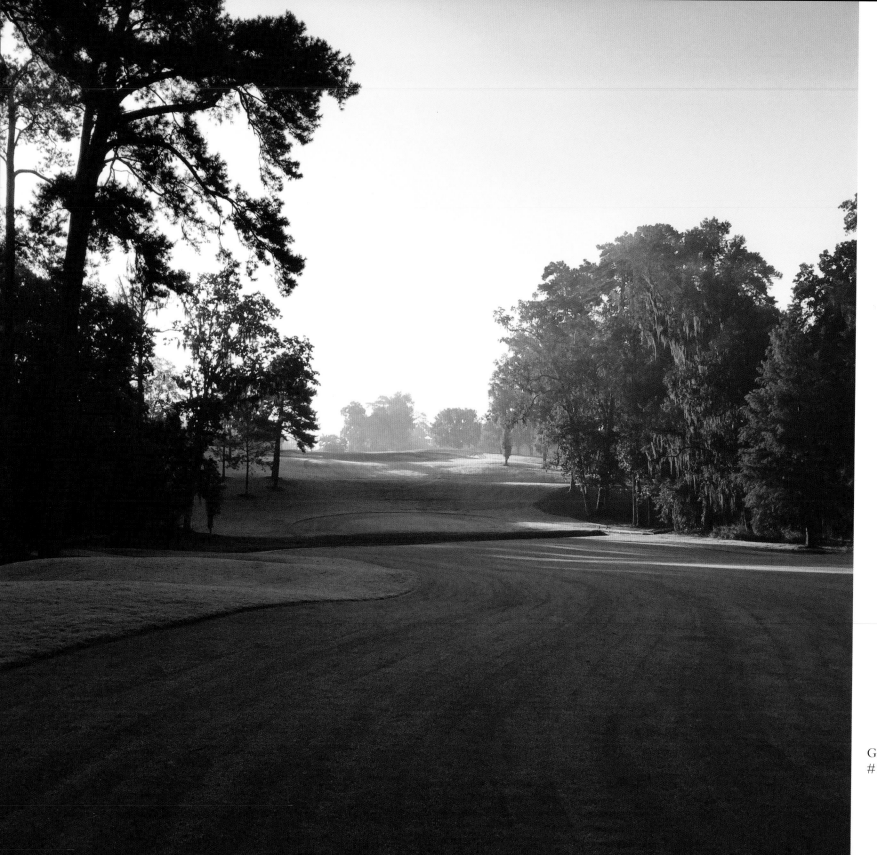

Glen Arven
#18.

A GREAT PROMISE

BEGINNINGS TO 1915

One key factor about golf remains the same after more than two hundred years of play in Georgia, despite changes in nearly every element of the game, including length of golf courses, enhanced equipment and revised rules. That perennial factor is the "eureka" moment when a golfer hits a good shot, whether it is a long, straight drive; an approach shot that ends up close to the hole; or a putt made from eighteen feet. That thrill in overcoming the challenges of golf is what has brought people back to play again and again from the game's earliest days. It is an excitement that can be experienced by the highest-handicap duffer, as well as the competitor about to win The Masters Tournament, or whether a golfer is age six or eighty-six.

Golf came to Georgia in the late 1700s. Two hundred years later, with more than four hundred golf facilities around the state, hosting The Masters annually and other significant amateur and professional events, golf is a year-long activity in Georgia. As stated in a 2010 study by Golf 20/20, a golf industry advocacy group:

It is also a key industry contributing to the vitality of Georgia's economy. In 2009, the size of Georgia's direct golf economy was approximately $2.4 billion. Golf brings visitors to the state, drives new construction and residential development, generates retail sales, and creates demand for a myriad of goods and services. When the total economic impact of Georgia's golf-related activities is considered, the golf industry generated approximately $5.1 billion of direct, indirect and induced economic output, $1.5 billion of wage income, and 56,922 jobs in 2009.

This is what has developed from the casual swings and putts of a few people in Savannah in the 1790s.

The game that developed in America in the 1890s, when the sport really took hold, was different from that played today. The length of a typical golf course did not exceed 6,400 yards, including the courses where the U.S. Open was held for its first thirty years (beginning in 1895)—such as Myopia Hunt Club north of Boston, 6,130 yards when it hosted the event in 1901. The number of clubs a golfer was allowed to carry was not restricted until the 1930s. Some golfers would carry more than thirty clubs, no small burden for the caddies of that earlier era. Clubs featured wooden

shafts, and polished persimmon wood formed the heads on drivers. Bob Jones won all his titles with wood-shafted clubs and drivers with wooden heads. In fact, the USGA prohibited the use of steel-shafted clubs in its championships for many years. When the 1929 U.S. Ryder Cup team participated in the matches in England, its members were forced to use hickory-shafted clubs because the Royal & Ancient (R&A) had not yet approved steel-shafted clubs. It was not until 1931 that a golfer, Billy Burke, won the U.S. Open with steel-shafted clubs.

Golf balls had limited flight in the 1890s, which was improved somewhat by the Haskell rubber-core ball, introduced in 1898. Uneven and inadequate conditioning of golf courses resulted in an approach shot that might plug in damp soil in front of a green on one hole and then bounce on hard soil in front of a green on the next. Some bunkers could have barely a quarter-inch cover of sand, and some bunkers featured four inches of sand. Mowing equipment could not achieve the contemporary measure of Stimpmeter speeds of better than seven or eight on the greens of most courses, if that. (Edward S. Stimpson Sr., Massachusetts state amateur champion and Harvard golf team captain, introduced the Stimpmeter device in 1935; it has since been modified by the USGA.) The grain of the grass—the direction in which it grew—affected putts because the grass had sufficient length to alter the line of a putt.

Many courses in the South had only sand greens, a circumstance that lasted into the 1930s. Pinehurst #2 in North Carolina, now a regular venue for the U.S. Open, did not have grass greens until the 1930s. Mules pulling a dirt mover shaped like a large pan predated bulldozers and backhoes for the shaping of fairways and greens. Because it was so difficult to move large amounts of dirt with the available construction methods, this limited the sites that were suitable for the creation of a golf course.

The game as played in America from 1890 until 1930 held amateurs in high esteem. But once Bobby Jones retired from competitive golf in 1930, only one amateur won a major championship that also had professionals participating: Johnny

The Savannah Golf Club clubhouse in the early 1900s.

Goodman won the 1933 U.S. Open, making him the fifth amateur to win the event and, to date, the last. Professionals were treated poorly in the early years of golf's growth in America, including being denied entry into clubhouses even during tournaments. The foundation of the Professional Golfers Association (PGA) in 1916, initiated by Rodman Wanamaker of Philadelphia, helped establish uniform standards for the skills of club professionals and brought respect to the position. It also helped in the creation of professional golf tournaments, which eventually became the PGA Tour. As stated by Al Barkow in *The History of the PGA Tour*, "Many of the players who were most instrumental in forming a tournament circuit were members [of the PGA] and the association was the logical organization to nurture the circuit and give it credence." But even in the 1916 U.S Open, out of the top thirty-eight finishers in the event, the lone amateur, Charles "Chick" Evans, won the championship. Three years before that, amateur Francis Ouimet, at age twenty, had astonished the sports world by defeating Harry Vardon and Ted Ray, two of the best professionals in the game, in a playoff to win the U.S. Open.

Professionals did excel in the game. The only man to win the U.S. Open three years consecutively, from 1903 to 1905, was Scotsman Willie Anderson, a professional. He also won in 1901, making him one of only five golfers to win four U.S. Opens; the others were Bobby Jones, Ben Hogan, Jack Nicklaus and Tiger Woods. George Sargent, a club professional who became head professional at East Lake in 1932, won the U.S. Open in 1909. Walter Hagen first won a U.S. Open in 1914, repeating in 1919. He won the PGA Championship in 1921 and then won four in a row from 1924 through 1927. Hagen won thirty-three tournaments from 1916 to 1929. Jim Barnes is credited with winning five professional events in a year as early as 1919. By 1927, there were more than thirty professional events from California to Texas to Florida, with Johnny Farrell winning seven that year. Horton Smith won eight events in 1929, and Gene Sarazen won that many in 1930. Smith went on to win The Masters in 1934 and 1936, and he played on eight Ryder Cup teams. But for all these achievements, there was little compensation. In some cases, the award for winning a PGA Tour event was a giant cake. Financial compensation was minimal. Usually, only the top twelve to eighteen finishers in a tournament got any compensation, a situation that did not change until after World War II.

In the early 1920s, the first prize for winning the U.S. Open was $500. The total purse for all entrants in PGA Tour tournaments held in 1925 in Corpus Christi, Houston and Beaumont, Texas, was $1,000 for each city, split among only those who finished in the money. The New Orleans tournament that followed had a $3,000 total

Golfers in the attire of about 1910.

purse. As late as the 1940s, the winner's share of The Masters was $1,500. Because of these limited earning opportunities from tournaments, nearly all the players who competed on the professional circuit had club professional positions. The series of professional tournaments occurred mainly during the

winter months, before the club professionals needed to be back at work tending to their club members and the pro shops at their home courses.

That the game grew quickly and dramatically in the United States is easily measured. In 1894, delegates from the Newport Country Club; Saint Andrew's Golf Club in Yonkers, New York; the Country Club in Boston; Chicago Golf Club; and Shinnecock Hills Golf Club on Long Island met in New York City to form what was to become the United States Golf Association (USGA). By 1910, there were nearly three hundred clubs across the nation. Georgia participated in this growth.

The population of Georgia in the 1890s was small, with only fifty thousand living in Atlanta when the Capital City Club was founded in 1883 as a downtown social club, later adding a permanent golf resource when the club purchased Brookhaven Country Club in 1915. The state's population was predominately rural, and its economy was driven by agriculture. Yet Georgia enjoys a significant place in the earliest history of the game in America. Savannah Golf Club dates back to at least 1794. In 1796, the *Georgia Gazette* published a notice of the annual general meeting for a golf club in Savannah. Several archival materials, such as club notices and invitations to club events, clearly establish this date for the existence of the club. An invitation to the meeting in 1796 read, "The honor of Miss Eliza Johnston's company is requested to a Ball to be given by members of the golf club of this city, at the Exchange, on Tuesday evening the 31st instant at 7:00 o'clock." The invitation signees included George Woodruff, Robert Mackay and James Dickson, who were managers, and George Hogarth, the treasurer.

What is remarkable about the club's origins is that only thirty years before the Savannah club's founding, the Old Course in St. Andrews, Scotland, whose site had been used for golf for hundreds of years previously, in 1764 set the now recognized eighteen-number-of-holes standard for the game. Accounts of golf being played in Scotland go back more than four hundred years before that. The diary of James Melville,

born in 1556, provides one example of the lineage of the game. He states that from the age of six, he was taught "to use the glubb for goff" at Montrose, a still active course situated about thirty miles up the coast from Carnoustie.

Golf had come to America by the late 1600s, with golf clubs and balls listed among bills of lading for merchandise delivered to plantation owners in Virginia. Benjamin Rush, a Philadelphia doctor who had his medical training at the University of Edinburgh in Scotland from 1766 to 1768, spread the word about the health benefits of golf when he returned to pre-Revolution America, eight years before he joined those who signed the Declaration of Independence.

Savannah did not create a lasting golf course in the 1700s, nor was the Savannah Golf Club that is known today incorporated until December 29, 1899, in Chatham County, Georgia. But for there to be an organization that identified itself as a golf club, there must have been active players whose love for the game brought them together to share their appreciation of the challenges and joys of golf. Once the club established itself, it became a great supporter of the game, welcoming many tournaments, serving seven times as host to

The Glen Arven clubhouse in the early 1900s.

the Georgia State Amateur Championship and three times to the Women's State Amateur and hosting many other events.

Wealthy visitors to Georgia should be credited for two of the next courses developed in the state, at Jekyll Island and at Glen Arven in Thomasville. Both became recreational retreats for many of the successful industrialists and financiers of the North, with golf added to other pursuits such as horseback riding, hunting, carriage rides and swimming at the beach on Jekyll Island and in the lakes around Glen Arven until a pool was built. Listed among the 1895 officers and governors of Glen Arven were residents of New York City, Boston, Philadelphia, Cleveland, Pittsburgh and Milwaukee. The club derives its name from Glen Arven Park, the hunting preserve of one of the vacationers, J. Wyman Jones of Englewood, New Jersey.

The first nine-hole course at Glen Arven opened in 1892, with the first clubhouse built in 1895. The club's golf course is considered to be the oldest continuously used site for golf in the state. The club, very early in its history, nurtured excellent golfers. Club member Beatrix Hoyt won three of the first four U.S. Women's Amateur Championships, and member Frances Griscom won in 1900. The club has hosted many important golf championships over the years, including three Georgia Women's Amateurs, one Georgia Men's Amateur and PGA Tour events in the 1930s.

Another Glen Arven member had a major impact on how golf was played everywhere. Though Coburn Haskell wasn't a member in 1898, when he developed the Haskell golf ball—the first ball with a rubber core circled by rubber strands—he eventually purchased Winnstead Plantation in Thomasville and became associated with Glen Arven, bringing the club renown. Walter J. Travis won the 1901 U.S. Amateur with a Haskell ball; Sandy Herd won the 1902 British Open with a Haskell; and Lawrence Auchterlone won the 1902 U.S. Open with a Haskell. These victories and others convinced golfers that the ball, which could be hit farther than the gutta-percha balls then in use, must be used in order to keep up with the competition.

Jekyll Island's first course.

In 1896, one year after Glen Arven opened its first nine holes, the Piedmont Driving Club (PDC), founded in 1887, created a seven-hole course that did not last on land that is now Piedmont Park in Atlanta. Some of those golf holes survived as a public golf course from 1904, when the land was sold for the public park, into the 1970s. A century after that first effort, PDC had Rees Jones design a course off Camp Creek Parkway in southwest Atlanta. This is now the club's golf resource.

Jekyll Island developed almost exclusively due to the involvement of northerners. However, the two principal initiators of the real estate element were Newton Finney, who served briefly on Robert E. Lee's staff as captain of engineers during the Civil War, and his brother-in-law, John Eugene DuBignon. These gentlemen purchased the land and attracted the interest of the northern visitors who ultimately bought and developed Jekyll Island. The February 1904 issue

Alfred Bourne and Fielding Wallace, active at Augusta Country Club and among the founding members of Augusta National Golf Club.

of *Munsey's* magazine described the Jekyll Island Club as "the richest, the most exclusive, the most inaccessible club in the world."

While the first golf course at Jekyll Island did not open until 1899, the wealthy residents who built large cottages there certainly played golf before then, hitting balls on the lawns. Willie Dunn Jr. laid out the 1899 course on Jekyll Island. He was influential in bringing Horace Rawlins, an Englishman who won the first U.S. Open in 1895, to work as the club's head professional when the Jekyll Island course opened in 1899. Dunn counted among his golf students Teddy Roosevelt, W.K. Vanderbilt and Stewart Maiden, whose golf swing Bobby Jones imitated as a young man and thus learned the game of golf. In 1910, a Donald Ross course opened at Jekyll, a layout incorporated into the Oleander course today. Then, in 1926, Walter Travis, winner of the 1900, 1901 and 1903 U.S. Amateur Championships, designed the Great Dunes course that opened in 1928, nine holes of which were lost years later due to development of a road close to the shore.

Tourism from northerners also inspired the creation of Augusta Country Club (ACC), but that club originally had a majority of its members from its local residents, complemented during the winter months by visitors from the North. In 1892, nearby Aiken, South Carolina, saw the establishment of Palmetto Golf Club in an area primarily known for thoroughbred

Augusta Country Club in the early 1900s. Note the sand green.

horses and polo but with a fair share of golfers. A full eighteen-hole course did not open there until 1897. Alfred Bourne, who played a role in the founding of Augusta National Golf Club in the 1930s, was a member at Palmetto, as well as at Augusta Country Club, in the 1920s. Augusta resident Fielding Wallace was among those who founded Augusta Country Club. Wallace went on to help found the Georgia State Golf Association in the 1920s, serving as its president from 1938 until 1945. He assisted Bobby Jones with the founding of Augusta National Golf Club in 1934 and was the first person from the South to serve as president of the United States Golf Association, from 1948 to 1950.

A fine golfer, Wallace performed well when ACC hosted the State Amateur Championship for the first time in 1921. Six State Amateurs have been held at the club, with club member Frank Mulherin Jr. winning the 1937 event contested at ACC. In 1991, club member Harry Claussen took eventual winner Neal Hendee to three holes of a playoff before finishing as runner-up. Charles Howell III,

whose family's home club was ACC as he grew up, attained the rank of number one junior in the United States during 1996. He subsequently played on the PGA Tour, where his two wins contributed to over $20 million in career earnings.

Chartered as a private club in 1898, the original site of the Atlanta Athletic Club was located on Edgewood Avenue in downtown Atlanta. Through the ages, the club twice outgrew its downtown space and eventually built a ten-story structure. That site would ultimately be sold in 1972 and demolished in 1973. Club member William Pinckney Hill made the recommendation that the club add golf as a resource in 1904, anticipating that the expense would be $1,500. The East Lake site provided the club with a golf course and country club in 1906, upgraded by architect Tom Bendelow in 1910 and then revised again in 1914. The Atlanta Athletic Club moved to the present Johns Creek location in the late 1960s, while East Lake Golf Club was restored in the 1990s. Bobby Jones, born in 1902, learned golf at the East Lake site, which was easily accessible since his family lived across the street from the course. Jones became one of the greatest players in the game, but he also served as president of the Atlanta Athletic Club, initiated the process of bringing the U.S. Open to the club's Johns Creek location and remained an active Atlanta Athletic Club member until he passed away in 1971.

Jones claimed in his autobiography, *Down the Fairway*, written with O.B. Keeler, that his first competitive round was at age six, which would have been in 1908. A six-hole match at East Lake was arranged among Jones, Alexa Stirling, Frank Meador and Perry Adair. Jones won the match and was given a three-inch-tall cup for the victory. It made a great impression on him. "I took it to bed with me that night," wrote Jones in 1927. "I've a hundred and twenty cups and vases now, and thirty medals, but there's one little cup that never fails of being kept well polished." Thirty years later, when he was presented with a silver casket to commemorate his visit to St. Andrews, he commented that the tiny cup he won at age six had always been first in his heart, but that from that point forward, the gift from St. Andrews would be of equal importance to him.

Stewart Maiden

Bobby Jones claimed that he learned how to play golf by following Stewart Maiden, Atlanta Athletic Club's head golf professional, around the golf course when he took up the game, but he never took a formal lesson from Maiden. That influence has a long heritage. Maiden learned golf from Willie Dunn Junior (1865–1952), originally from Musselburgh, Scotland. After arriving in America, Dunn played a role in designing Shinnecock Hills on Long Island in its early years. In Georgia, Dunn laid out the 1899 course at Jekyll Island. Willie Dunn learned golf from his father, Willie Dunn Sr. (1821–1878), in Scotland.

Jimmy Maiden, Stewart Maiden's brother, preceded Stewart as golf professional at the Athletic Club at East Lake. Bobby Jones's parents began taking golf lessons from Jimmy as early as the summer of 1907, when Bobby would have been five. In 1908, Stewart Maiden replaced his brother as golf professional at the Athletic Club. Bobby's introduction to Stewart came when the pro joined Bobby's parents for a round of golf. Bobby at that time was only an observer of what was happening, not a participant. He would follow Maiden when he played, observing what Maiden did, and then he would try to mimic Maiden's techniques on the practice tee. Bobby Jones never took a formal lesson from Maiden; however, Maiden would coach Jones about one aspect or another of his game if the young golfer was having a problem. He even attended some of Jones's tournaments during his competitive years. As O.B. Keeler, Jones's friend and chronicler of his golf career, said of Maiden, "Stewart almost invariably was able to straighten out the kinks in Bobby's own method, so exactly modeled on Stewart's own play."

Jones said of his mentor, "Stewart had the finest and soundest style I have ever seen. Naturally, I did not know this at the time, but I grew up swinging like him. I imitated his style, like a monkey I suppose."

Stewart Maiden.

Maiden's thoughts and techniques on the golf swing produced star pupils like Alexa Stirling, winner of three consecutive U.S. Women's Amateurs in 1916, 1919, 1920 (no events were held in 1917 or 1918 due to World War I); Perry Adair, winner of the Georgia State Amateur Championship; Charlie Yates, winner of the British Amateur Championship; and, of course, Bobby Jones.

Part of what is so impressive about the influence Maiden had on his pupils is that he taught a modern golf swing—but one hundred years ago. Today, while looking at film of Jones in his prime, he appears to be a golfer who could walk out to the first tee in a U.S. Open and challenge for the title. Jones's rhythmic swing, using a full turn of his whole body, contrasts with the greats of the generation before him, Harry Vardon and Ted Ray, who were more active with their arms.

Coosa Country Club.

As noted earlier, Jones developed his golf swing by imitating Stewart Maiden, whom he observed on the course at East Lake during his golf rounds. Jones imitated Maiden so accurately that he could be mistaken for Maiden, which happened in 1917. "I grew up swinging so precisely like Stewart," he said, "that when I was about fifteen years old and a chunky kid about Stewart's size and shape—I was playing in long pants in those days, as Stewart always has played—an old friend of Stewart's mistook me for him on the Roebuck Country Club course at Birmingham." When the friend of Maiden's was informed by Jones's father that he was mistaken about whom he had seen, the friend replied, "You can't fool me. I saw Stewart drive just now from the tenth tee. Think I don't know that old Carnoustie swing?"

George Adair, father of Bobby Jones's friend and competitor Perry Adair, played a role in the renovation of the course at East Lake in 1914 and 1915, with the course design work attributed to Donald Ross, who did further work at the club in 1925 and then, in 1928, designed a second course for the club that no longer exists.

Golf had begun to spread around the state by 1908 and over the next few years, with the addition of clubs in Rome, Columbus, Dalton and Quitman and several in Atlanta. Coosa Country Club in Rome was organized on a temporary basis in August 1909, with Robert W. Graves, president; J.P. Cooper, vice-president; George Watts, secretary; and H.E. Kelley, treasurer. Beginning with ten acres of property along a bend of the Coosa River, additional land was secured for expansion. There was already a makeshift golf course on the property. The first clubhouse and formal christening of the club were celebrated with two receptions and a ball in the afternoon and evening of March 29, 1910. The stockholders met two days later to make the temporary organization permanent. The golf course was originally only nine holes but soon was expanded to eighteen. Designer George Cobb is credited with renovating the course in 1973. His work includes Doublegate Country Club in Albany, Green Island Country Club in Columbus and the par 3 course at Augusta National Golf Club, done in conjunction

with Bobby Jones. Validation of the quality of the golf course at Coosa Country Club is seen in the fact that it has been host to the Georgia State Amateur Championship seven times, most recently in 2006.

The club endured one major setback in the 1950s that was overcome readily. After celebrating the construction and opening of a new clubhouse in August 1959, the structure suffered considerable damage in a fire on December 29, 1959. Insurance covered the damages, and the clubhouse was restored, reopening in July 1960. A $7.5 million renovation project in 1999 upgraded the clubhouse again, this time to a fifty-thousand-square-foot structure.

Established in 1909, the Country Club of Columbus boasts a golf course designed by Donald Ross, with its layout opened in 1915 to 6,515 yards as a par 71. Restored in 2002, the intention was to bring back features of the original Ross design. A true championship course, the club has hosted many Georgia State Golf Association events over the years, including the 1982 and 1990 Junior Boys' and Girls' Championships; the 1998 and 2007 Mid-Amateur Championships; and the 1925, 1947 and 1960 Georgia Amateur Championships, as well as the 2004 Georgia Senior Championship. The Georgia State Amateur returned in 2009 to honor the club's one-hundred-year anniversary. The prestigious Southeastern Amateur Championship has been held at the club since 1922. The club has had three members serve as presidents of the GSGA: Bill Zimmerman, 1956 to 1957; Richard Wilson, 2002 to 2004; and Seth Knight III, 2007 to 2008. Club member Carter Mize won the State Amateur in 1993 and 1994.

Club member Hugh Royer Jr.'s first win in tournament golf was the All-Southern Junior in 1949, at the age of thirteen. In 1958, he won both the Georgia Amateur and the Southern Amateur. Royer turned professional in 1959 and won both the St. Charles Open and the Western Open on the PGA Tour. He spent most of his career as a club professional, winning the Georgia PGA Championship twice, in addition to the Georgia Open and Georgia Senior

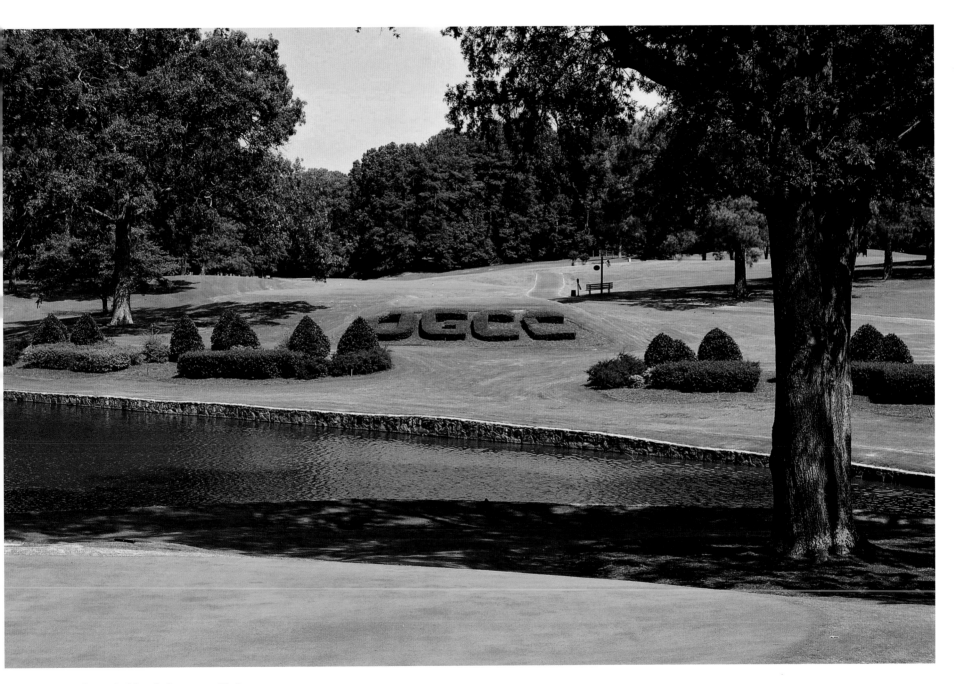

Dalton Golf and Country Club.

Druid Hills Country Club in the 1920s.

In August 1915, thirteen-year-old Bobby Jones, a junior member at Druid Hills, as well as at Atlanta Athletic Club, won the club championship. A son of Druid Hills and Atlanta Athletic Club member George Adair, Perry Adair would finish second to Jones in the 1916 State Amateur and then make the trip to Merion in Philadelphia to compete in the U.S. Amateur that year. Perry won the State Amateur Championship in 1922, a year his home club hosted the event.

In 1920, Druid Hills hosted the Georgia State Amateur Championship, won by club member C.V. Rainwater, who beat Bobby Jones one up in the semifinals on his way to victory. That year, Charley Black joined the club as a junior member, and he won the State Amateur in 1928. Tommy Barnes, who joined the club as a junior member in 1938, won the first Dogwood Invitational at Druid Hills in 1941. It is still an important amateur tournament today.

Another addition to Atlanta's golf resources in 1912 was Ansley Golf Club. Part of a planned residential development, the original plans called for an eighteen-hole golf course, but only nine holes were built. In 2004, the club purchased Settindown Creek in Roswell, a northern suburb of Atlanta, a Bob Cupp design. In 2005, the Settindown Creek course hosted the Women's U.S. Amateur Championship, won by Morgan Pressel 9 and 8 in the final over Manu Martinez.

Ansley club member Gene McClure has been active in service to golf for more than thirty years, serving as president of the GSGA in 1996 and 1997 and as committeeman for the USGA for more than twenty years. From 2008 to 2012, McClure served as a member of the USGA's Executive Committee, where his knowledge benefitted the GHIN, Mid-Amateur and Regional Affairs Committees. He was co-chairman of the 2005 U.S. Women's Amateur Championship. In 2008, McClure was the recipient of the Joe Dey Award, presented by the USGA for his service to the world of golf as a volunteer.

Proving that golf reached into every corner of the state fairly quickly, in 1912, Dalton Golf and Country Club was founded. Its first course was located at the corner of Ridge and West

Open. Royer served as president of the Georgia PGA and was the Georgia Golf Professional of the Year in 1983.

Chartered in 1912, Druid Hills Golf Club featured a course designed by Englishman H.H. Barker, a winner of the Irish Open in 1906. Barker became a golf course designer after moving to the United States in 1908. Among his first designs was the Columbia Country Club outside Washington, D.C., still one of the premier clubs in that area. The Capital City Club course, originally known as Brookhaven Country Club, in Atlanta was also a Barker design.

Atlanta's population was around 160,000 when Druid Hills opened. Among the first members of the club were many prominent Atlantans whose names are still attached to city features, including Asa Candler, John W. Grant, Edward H. Inman, Joseph T. Orme and Ernest Woodruff. Founding member C.V. Rainwater served as president of the Georgia State Golf Association from 1934 to 1936. Lowery Arnold, a member of Druid Hills's first board of directors, served as president of the Georgia State Golf Association from its establishment in 1924 through 1933, as well as of the Southern Golf Association from 1930 to 1933.

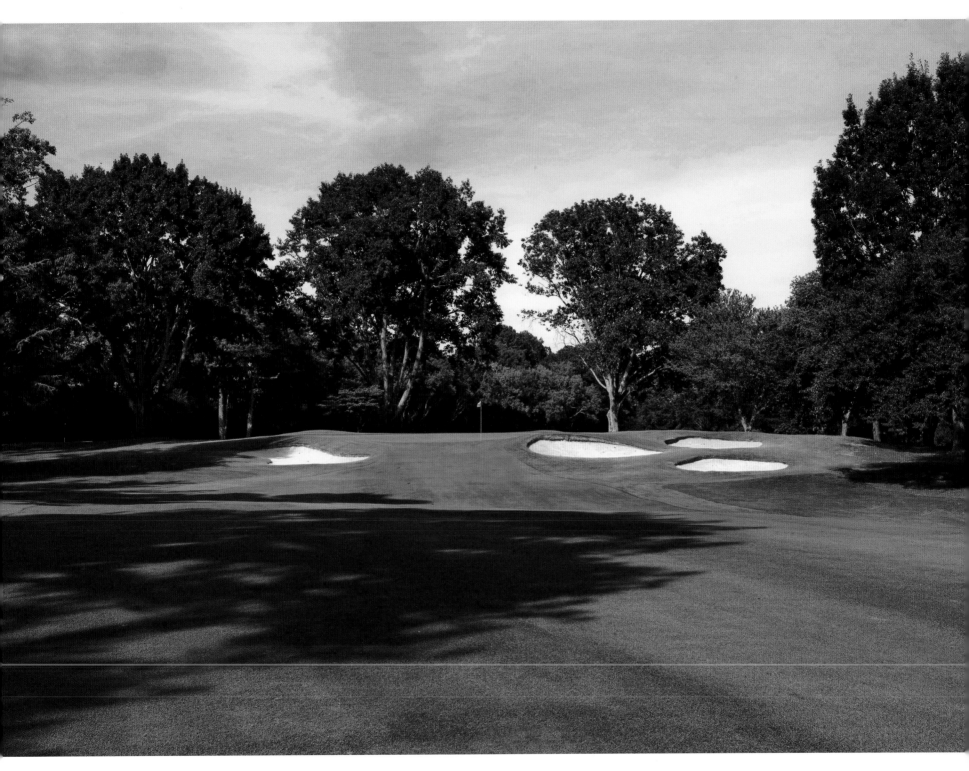

Idle Hour.

Emory Streets, within the city limits of Dalton. By 1924, the club had moved twice, and a new nine holes were completed in Willowdale, with an additional nine holes added in 1969. When the first nine holes opened in 1924, the greens were made from a mixture of cotton seed hulls and oil, rolled with a heavy roller to achieve a smooth texture. During the 1940s, the club installed grass greens. Since the early 1950s, the club has hosted the North Georgia Invitational Tournament, with Georgia State Amateur champion Charlie Harrison among the winners of the event. Several talented players have been affiliated with the club, including Bill McDonald, Clay Dykes Jr. and Michael Clark II. Former senior club champion Andy Bargeon served as president of the GSGA in 1991 and 1992.

Macon's Idle Hour Country Club began as a nineteenth-century social organization known as the Log Cabin Club, whose log clubhouse, just outside the city limits of Macon, allowed members to enjoy dining, dancing, card games, shooting, cycling, tennis and golf. In 1911, the club moved to Idle Hour Stock Farm and racetrack. In 1912, Idle Hour Country Club incorporated, featuring a new golf course created by club members. That original layout has since been renovated on two separate occasions, once by Willard Byrd and again by Brian Silva. The club has been a popular venue for the State Amateur Championship, the first held in 1923 and won that year by Watts Gunn. The Amateur returned in 1940, this time won by Jennings Gordon of Rome. Thirteen years later, E. Harvie Ward won the Amateur at Idle Hour, defeating Arnold Blum in the final, 5 and 3. In 1968, Toby Browne of Savannah won the Amateur at the club. A decade later, in 1978, Allen Doyle won the event, followed by Tim O'Neal in 1997, Russell Henley in 2008 and Robert Mize in 2014. Through 2015, Idle Hour, with eight Amateur Championships, has hosted more than any other club in Georgia.

Capital City Club's Brookhaven course began as Brookhaven Country Club in 1910 with a nine-hole course. In 1913, Capital City Club signed a lease-purchase agreement for the site, completing the transaction in 1915 and extending the golf course to eighteen holes that year. Of the original sixteen members in charge of planning and organizing Brookhaven, ten were members of Capital City Club in 1913. In October of that year, the club was host to an exhibition match by English champions Harry Vardon, six-time winner of the British Open, and Edward Ray. By 1916, the Brookhaven site would host the first State Amateur Championship.

The present Brookhaven clubhouse building was erected in 1928 and expanded several times over the years. Continuing its heritage of hosting competitive golf, the Brookhaven course hosted many State Amateur Championships after 1916, including in 1926, 1932, 1936 and 1946. The event will return to Brookhaven in 2016. Other events the course has hosted include ten Atlanta Amateur Championships and the Women's Western Open in 1947 and 1953, both of the latter events being won by club member Louise Suggs.

The Capital City Club Crabapple site was built in 2002 with a golf course designed by Tom Fazio. The course immediately hosted a PGA Tour event—the World Golf Championship of 2003, won by Tiger Woods—establishing the layout as one of the best in the Southeast. In recent years, the Crabapple course has continued the Capital City Club's heritage of hosting tournaments, with the AJGA Canon Cup, The Rolex Junior and the NCAA Men's Division I Championship all being held there. The 2016 State Amateur Championship will be held at CCC's Crabapple course for qualifying, and then the low thirty-two qualifiers will compete at match play at the Brookhaven course, redesigned by Bob Cupp in 2009, to determine the champion. In 2017, the club will serve as the host site for the U.S. Mid-Amateur Championship. This will be the first USGA Championship held at the Capital City Club. The companion course for the stroke play portion of the Mid-Amateur Championship will be the Atlanta National Golf Club. Atlanta National, designed by Pete and P.B. Dye, opened in 1988 and is part of ClubCorp. Based in Dallas, Texas, ClubCorp was founded in 1957. It owns or operates more than two hundred golf and country clubs, business clubs, sports clubs and alumni clubs in twenty-six states, the District of Columbia and two foreign countries.

Proving that even Bobby Jones had to develop his game, in 1914, an Atlanta city championship was held with nearly one hundred participants from the four clubs in the city: Druid Hills, Capital City Club, Ansley and Atlanta Athletic Club. It was the largest field ever assembled for a tournament in Atlanta, and the *Atlanta Journal* at the time called it the second-largest tournament ever held in the South. Jones, twelve years old, shot 89 each day in the two qualifying rounds. Yet a reporter accurately said of Jones that he "gives the promise of becoming one of the South's foremost players within a very few years." In this tournament, Jones did not advance very far. George Adair, father of Jones's friend Perry Adair, won that first Atlanta city championship.

In a little over a decade since the first permanent clubs were established, golf had spread throughout Georgia to every corner of the state, from the North Georgia mountains to the Atlantic Coast. In the next fifteen years, more than twenty-five courses would be added in the state, further extending the reach and appeal of the game.

"There are…all over England," wrote George Birmingham, a British social critic, in 1914,

> *clubs especially devoted to particular objects, golf clubs, yacht clubs and so forth. In these the members are drawn together by their interest in a common pursuit, and are forced into some sort of acquaintanceship. But these are very different in spirit and intention from the American Country Club. It exists as a kind of center of the social life of the neighborhood…But neither golf nor tennis, dancing nor sailing, is the object of the club's existence. Sport is encouraged by these clubs for the sake of general sociability. In England sociability is a by-product of an interest in sport.*

While country clubs in Georgia may have fit the profile described by Birmingham, there can be no doubt that golf was the driving force to found the various clubs around the state.

Every level of American society enjoyed golf, some enjoying it more than others. During his presidency, Woodrow Wilson, who at one time practiced law in Atlanta, played golf almost daily, mainly as a way to improve his vulnerable health. According to biographer A. Scott Berg, in 1914 Wilson described the game of golf as being "an ineffectual attempt to put an elusive ball into an obscure hole with implements ill-adapted to the purpose."

East Lake #6.

A Remarkable Legacy

1916–1930

The Georgia State Amateur Championship has been won only once by a fourteen-year-old contestant: Bobby Jones in the first State Amateur held in 1916 at the Capital City Club's Brookhaven course. Jones, who at age fourteen was regularly driving the ball 250 yards, in the final that year beat his friend Perry Adair, who was sixteen. Impressed by the two boys' caliber of play, USGA committeeman Ralph Reed encouraged them to play in the U.S. Amateur at Merion, which required a handicap under six and a five-dollar registration fee. Jones qualified through stroke play and then advanced by winning his first two thirty-six-hole matches, the first against the 1906 U.S. Amateur champion, Eben M. Byers. Both players had trouble controlling their tempers and were prone to throwing their clubs. Jones finally won the match, 3 and 2. He would joke many years later that the only reason he won was because Byers ran out of clubs. In the quarterfinal, Jones lost to Robert Gardner, 5 and 3.

While a fourteen-year-old qualifying for a national championship would still be a remarkable feat even today, another notable aspect of Jones's and Adair's participation in that U.S. Amateur Championship is that very few golfers beyond the north section of the country had participated previously. All USGA championships featured a field heavily weighted with entrants from clubs throughout the Northeast. A few came from Chicago and even as far away as San Francisco, but Jones and Adair were two of the first participants from the South.

Golfer's magazine reported on "Little Bob" Jones's play at Merion:

> *It only required a glance at Jones for one to be speedily convinced that the boy from Atlanta was a golfer from top to bottom. There were times when with an easy and almost perfectly timed stroke he would get as much distance from the tee as the big chaps who had been playing the game much longer and had twice his strength. Bobby also has the happy faculty of imparting back spin to his ball with his mashie. It seemed to be natural with him; for that matter, everything he did was brought off without fuss or frills of any kind.*

The 1916 Georgia State Amateur Championship was pivotal for Jones's career in that it brought him recognition at the national level and his first opportunity to compete in a

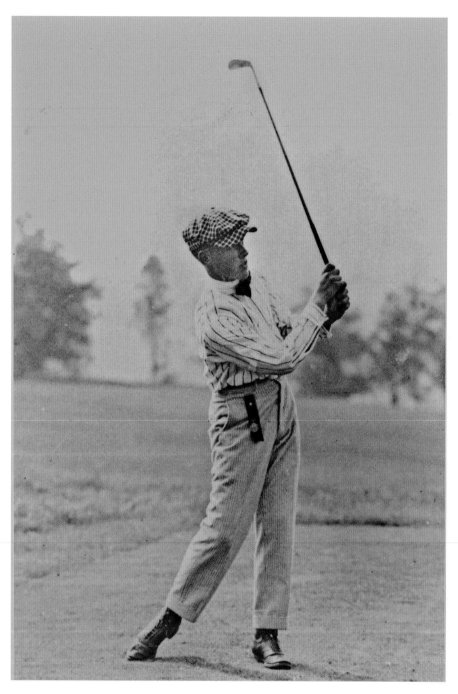

national championship. It was also significant for being the year the Georgia State Golf Association began to organize, at the time exclusively to oversee and implement the Georgia State Amateur Championship. During the week of the championship, the *Atlanta Journal*, on Tuesday, August 1, 1916, reported: "It is planned to make this tourney an annual affair, and there will most likely be formed a Georgia state golf association at this tourney, the association being formed for the sole purpose of holding this tourney each year, designating the city in which it is to be held, and conducting it." The anticipated organizational meeting was held on Friday of that week, the day before the finals of the championship were held. The organization did not file for an official charter until 1924, but it did operate the Georgia State Amateur Championships of 1916 through 1924. A two-year hiatus was necessary due to World War I in 1918 and 1919.

The Georgia State Golf Association (GSGA) officially incorporated in 1924 and was managed solely by volunteers over the next five decades, until the hiring of its first executive director in 1973. Several of the people involved in 1924 had been present for the 1916 State Amateur Championship won by Jones. Lowry Arnold is usually identified as the GSGA's first president from 1924 to 1933 because 1924 is the date the organization was officially chartered. However, in 1916, Dr. J.A. Selden of Macon was named in the *Atlanta Journal* as the organization's president, with Lowry Arnold serving as a vice-president, along with Robert Hull, Savannah; Colonel Charlton E. Battle, Columbus; Garland Jones, Newnan; Fielding Wallace, Augusta; Frank Hardman, Athens; S.R. Marshall, Rome; and J.R. Pottle, Albany. Lloyd Parks of Atlanta served as secretary and treasurer. The various hometowns of the officers reflect the organization's true statewide scope. Plus, several of the

Bobby Jones at age fourteen, the year he won the first Georgia State Amateur Championship.

men were good players. Seldon, Arnold, Parks and Battle all competed in the first State Amateur Championship.

Immediately following the 1916 event, planning began for the next year's championship, won by Noble Hardee at Savannah Golf Club. World War I forced a hiatus for the event in 1918 and 1919, and then Crawford Rainwater won in 1920 at Druid Hills Golf Club, where he was a member. Montgomery Harison won at Augusta Country Club in 1921, with Rainwater finishing second. For the next three years, first-time winners prevailed in the championship: Perry Adair (1922), Watts Gunn (1923) and Carl Ridley (1924). Then, Eugene Cook became the first repeat champion, taking the honors in 1925 and 1926. Watts Gunn became another two-time winner with his victory at Savannah Golf Club in 1927. Charles Black won in 1928, and John Oliver won in 1929 at Radium Springs Country Club in Albany. By this point, the State Amateur Championship had been held throughout the state: Atlanta, Savannah, Augusta, Macon, Columbus and Albany.

The trophy that is awarded to the winner of the State Amateur was donated in 1925 by Robert H. "Bob" Martin. Originally from Washington, D.C., Martin became a member of Capital City Club in 1915 and played in the first Georgia State Amateur Championship hosted by the club. He served the club as a committeeman and became president in 1924. Martin was responsible for the hiring of Howard "Pop" Beckett, the second head professional at Capital City Club Brookhaven, who served from 1918 until 1952 and then as golf course superintendent for five years. Martin served on the board of directors of the GSGA when it formed in 1924.

Among its milestones, the GSGA began supporting turf grass research in 1959, rating courses in 1961, added the Junior Championship in 1966 and began administering the handicap system in 1972 before adding its first full-time staff director in 1973. The following decades saw extensive growth in members, volunteers, staff and services as the GSGA expanded its competitions program to include eighteen statewide events and four interstate matches, computerized the handicap system, formalized the course rating program, established a charitable foundation, started

Right: Perry Adair.

Below: Capital City Club Brookhaven, rear view of the clubhouse in 1916.

publishing *Golf Georgia* magazine and began managing the Georgia Golf Hall of Fame.

The group that conducted the first Georgia State Amateur Championship could not have known that its first champion would become one of the greatest golfers ever to play the

Robert H. Martin

Bob Martin.

The Robert H. Martin Trophy, presented each year to the State Amateur champion, was donated by Mr. Martin in 1925. Martin served on the first board of directors of the GSGA, and he was a member of Capital City Club, serving as president in 1924. Originally, winners' names were engraved on the trophy, but after Tommy Aaron's name went on in 1960, a wooden base was added in order to allow recognition for subsequent winners. Two champions' names are on both the trophy and the base: Frank Mulherin, who won in 1937 (trophy) and 1965 (base), and Jack Key, who won in 1949 (trophy) and 1961 (base). A new base had to be produced after 1996 because all the space was gone on the original. The current base has enough space for winners' names through 2032. When a GSGA member club investigated the cost to replicate the sterling silver trophy, the projected expense was $40,000. The club decided against the replica.

game. After Jones made his precocious entrance to the national level of competitive golf at the 1916 U.S. Amateur, he quickly proved that he could compete anywhere. In 1917, he won the Birmingham Country Club Invitation; the Cherokee Club Invitation in Knoxville, Tennessee; and the East Lake Invitation Tournament. In both 1917 and 1918, he won the Southern Amateur, playing golf mainly in exhibition matches during those years to generate funds for war relief efforts and to support the Red Cross. In 1919, he made it to the final of the U.S. Amateur but was defeated by S. Davidson Herron by 5 and 4. Although golf writer O.B. Keeler would characterize as "the lean years" the period of Jones's competitive golf career from 1916 until 1923, when he won his first major championship, the U.S. Open, Jones won the Southern Amateur in 1920 in Chattanooga and the Morris County Invitational in New Jersey that year. He made it to the semifinals of the State Amateur in 1920, losing to eventual champion C.V. Rainwater—the only appearance by Jones in the event after 1916. Jones again won the Southern Amateur in 1922 at East Lake, his final appearance in the event as he began to focus more on national events such as the U.S. Open and U.S. Amateur and international events such as the Walker Cup, the British Amateur and the British Open.

At this point in time, Jones was not the most accomplished Georgian in golf. In 1920, Atlanta's Alexa Stirling, who had joined Jones for Red Cross matches during 1918, won her third U.S. Women's Amateur Championship in a row. Born in Atlanta on September 5, 1897, Stirling knew Jones from their days at East Lake. It was three days before her nineteenth birthday when she won the first of her three U.S. Women's Amateur Championships in 1916, having first competed in the event the previous two years and been the first competitor from the South in the championship. After winning it again in 1919 and 1920, she placed second in that same tournament in 1921, '23 and '25. In 1920 and '34, she won the Canadian Women's Open, and she finished second in 1922 and '25. Throughout her life, she maintained her interest in golf and was an honorary member of the Royal Ottawa Golf Club, known by her married name, Alexa Stirling Fraser.

In late 1921, two of the foremost golfers of that era, Jim Barnes and Jock Hutchison, began a tour of forty-eight exhibition matches that would take them from Vancouver, British Columbia, on December 15 to Pinehurst, North Carolina, on March 23, 1922. Their stops along the way included

San Francisco, Los Angeles, Phoenix, Dallas and New Orleans. Barnes, winner of the 1921 U.S. Open and the 1916 and 1919 PGA Championships (the first two held), was to play a series of matches against Hutchison, winner of the 1920 PGA Championship and the 1921 British Open. That Open championship was notable for the incident in which, during the third round, Bobby Jones picked up his ball on the eleventh hole and tore up his scorecard, disqualifying himself, though he finished the event. Hutchison was playing with Jones on that day. When they got to the sixteenth hole, Jones slammed down his putter in disgust after missing a putt. Hutchison grabbed Jones by the arm and exclaimed, "Young man, we don't do that sort of thing here!" Showing that eventually Jones learned not only to control his temper but also to connect with those who suffered from his tantrums, years later Hutchison served as an honorary starter for The Masters at Jones's invitation.

The Barnes and Hutchison tour came to Macon on March 11 and then, two days later, stopped at Glen Arven in Thomasville. Jones was all too familiar with Barnes as well, having finished second to him in 1919 in the Southern Open held at the East Lake Course of the Atlanta Athletic Club and second to him earlier in the year at the Canadian Open. During that tournament, Barnes and Leo Diegel had defeated Jones and J. Douglas Edgar in an exhibition match. While the

Alexa Stirling.

accomplishments and appeal of Bobby Jones are usually identified as the inspiration for the growth of the game in Georgia, in 1922 Jones, at age twenty, was just graduating from Georgia Tech, having finished high school at sixteen. He did not win his first major championship until 1923, when he won the U.S. Open at Inwood Country Club in New York. The Barnes and Hutchison tour, by the range and scale of their appeal, shows how popular they were and that golf was beginning to get some of the attention usually restricted to baseball, boxing, football and horse racing. The Barnes and Hutchison tour attracted so much interest that the *New York Tribune* assigned Ray McCarthy, a sportswriter for the newspaper, to accompany the golfers and report on their matches, accounts that were published in the *Tribune* as well as syndicated to other publications.

In 1923, Fred Haskins started as head professional at the Country Club of Columbus, a position he held for thirty-four years, having been recommended for the position by Bobby Jones. Haskins's influence on golf in Georgia continues today. In Saturday morning classes that cost a nickel, he taught the junior members of the club. They went on to win more than 150 collegiate and amateur tournaments. Among State Amateur champions from the club have been Bill Zimmerman in 1935 (a year that club member Sonny Swift finished second, with Country Club of Columbus serving as the host site), George Hamer in 1947, Jack Key Jr. in 1949 and 1961, Hugh Royer Jr. in 1958, Billy Key in 1967, Bo Trotter in 1971, Hugh Royer III in 1986, Carter Mize in 1993 and 1994, Jimmy Beck in 2013 and Robert Mize, son of Masters champion Larry Mize, in 2014. Haskins, who served the club in other capacities after retiring as head professional, died in 1981. To honor Haskins's contributions to golf, the Fred Haskins Award was established in 1971 recognizing the year's outstanding college golfer. Recipients of the Haskins Award have won twenty-eight Majors and recorded more than 260 victories on the PGA and Champions tours. Recipients include Ben Crenshaw, Phil Mickelson, Justin Leonard, Stewart Cink,

Matt Kuchar, Luke Donald, Charles Howell III, Graeme McDowell, Hunter Mahan and Bill Haas, among other notable golfers.

The year Haskins came to Country Club of Columbus was also the year Jones broke through and won his first national championship: the U.S. Open at Inwood Country Club in Inwood, New York. Jones won an eighteen-hole playoff against Bobby Cruickshank by a score of 76 to 78 to win.

In 1924, Jones finished three shots behind U.S. Open winner Cyril Walker. He competed in his second Walker Cup in early September and then returned to Merion Cricket Club in Philadelphia for his second participation in a U.S. Amateur at that site. By this point, Jones had become the dominant player in the game. His last three matches in the event were won at 6 and 4 against Rudolf Knepper, 11 and 10 against Francis Ouimet and 9 and 8 against George Von Elm in the final.

The next year, Jones ended the U.S. Open tied with Seth MacFarlane, but how Jones got to that point established his reputation for character as much as his play established his ability. During the first round in the 1925 U.S. Open, Jones's approach shot to the elevated eleventh green fell short. The ball settled in deep grass on a steep embankment. After taking his stance, his club head brushed the grass and, according to Jones, moved the ball, but no one else saw it happen. Jones promptly informed his fellow competitor, Walter Hagen, and a USGA official that he had violated Rule 12 (4), found on page eighteen of the 1925 *USGA Rules of Golf* booklet, prohibiting moving a ball at rest after address (the current version is Rule 18-2b on page fifty-two in the 2014 *USGA Rules of Golf*). He assessed himself the required one-stroke penalty. Jones, after the round, signed his scorecard for a 77.

News spread about Jones's assessment of a penalty stroke for a violation that no one else had witnessed. Praise flowed from many quarters in testament to his inherent honesty and respect for the *Rules*. Jones scoffed at such a notion. "You'd as well praise me for not breaking into banks," he

said. At the time, the matter looked as though it would prove a fleeting but soon-to-be forgotten matter of honor because of his first-round score of 77. But Jones put together back-to-back rounds of 70 with a final round of 74 for a total of 291. The penalty stroke had cost him his second U.S. Open championship because, without it, there would have been no need for a playoff. He would have prevailed by a stroke. The playoff went to thirty-six holes, with MacFarlane prevailing 75–72 to Jones's 75–73. His decision to penalize himself made Jones runner-up for the third time in four years. In August of that year, Jones defeated his good friend Watts Gunn, from the Atlanta Athletic Club, 8 and 7 to win the U.S. Amateur. It is still the only time two members from the same club have faced off in the finals of the U.S. Amateur.

The *Rules* incident was not forgotten. The centerpiece of the USGA's Annual Meeting remains the presentation of the association's highest honor: the Bob Jones Award. Since 1955, it is given annually in recognition of distinguished sportsmanship. The award seeks to recognize a person who emulates Jones's spirit, personal qualities and attitude toward the game and its players. And it is coveted by those who appreciate what it means to be linked forever to the name of Bob Jones. Charlie Yates Sr. and Thomas Cousins are two Georgians who have received the award.

His regard for strict adherence to the *Rules of Golf* never flagged throughout his life. In his book *Golf Is My Game*, published in 1960, Jones featured a section entitled "Respect the Rules and Etiquette of the Game." He wrote, "It is of the very essence of golf that it should be played in a completely sociable atmosphere conducive to the utmost in courtesy and consideration of one player for the others, and upon the very highest level in matters of sportsmanship, observance of the rules, and fair play."

In 1926, Jones again made the Walker Cup team, with the matches scheduled June 2 and 3 for the Old Course at St. Andrews in Scotland. Participating on the team provided Jones with the opportunity to also enter the British Amateur at Muirfield Golf Club to be held on May 24–29, and the British Open at Royal Lytham and St. Annes in Southport, England. In the Amateur, Jones made it to the sixth round, where he was eliminated by Andrew Jamieson Jr. In the Walker Cup matches, Jones helped the U.S. team prevail by six to five. In the British Open, Jones won by two strokes over Al Watrous with a score of 291, which tied the British Open record at that time. In the fall of 1926, Jones entered Emory University Law School.

At the U.S. Open in 1927, Jones had one of the worst performances of his career, though other players might have been satisfied with it. He finished tied for eleventh, eight shots behind winner Tommy Armour. When he defended his British Open title a month later at the Old Course, he won by a six-shot margin. He came home and won the U.S. Amateur at Minnikahda Club in Minneapolis, Minnesota, thumping Chick Evans in the final by 8 and 7.

The next year in the U.S. Open at Olympia Fields Country Club in Chicago, Jones encountered another thirty-six-hole playoff, this time losing by one shot to Johnny Farrell, who scored 70–73 to Jones's 73–71. Jones competed on another winning U.S. Walker Cup team in August and then played in the U.S. Amateur in September. He won his last three matches by overwhelming margins: 14 and 13 over John B. Beck, 13 and 12 over Phillips Finlay and 10 and 9 in the final against T. Phillip Perkins, who won the 1928 British Amateur.

At the U.S. Open in 1929 at Winged Foot, Jones faced his third playoff in the championship. Although Al Espinosa tied Jones at the end of regulation play, in the thirty-six-hole playoff Jones left him behind, besting Espinosa by twenty-three strokes. In September, Jones went to Pebble Beach in California for the U.S. Amateur, where remarkably Johnny Goodman eliminated Jones in their first-round match. Jones did take the opportunity while on the Monterey Peninsula to play Cypress Point, which Alister MacKenzie designed. Mackenzie had also contributed to the renovation of Pebble Beach during 1928. Jones so liked both courses that when he decided to create his own club in 1931, it was MacKenzie whom he selected to be the course architect.

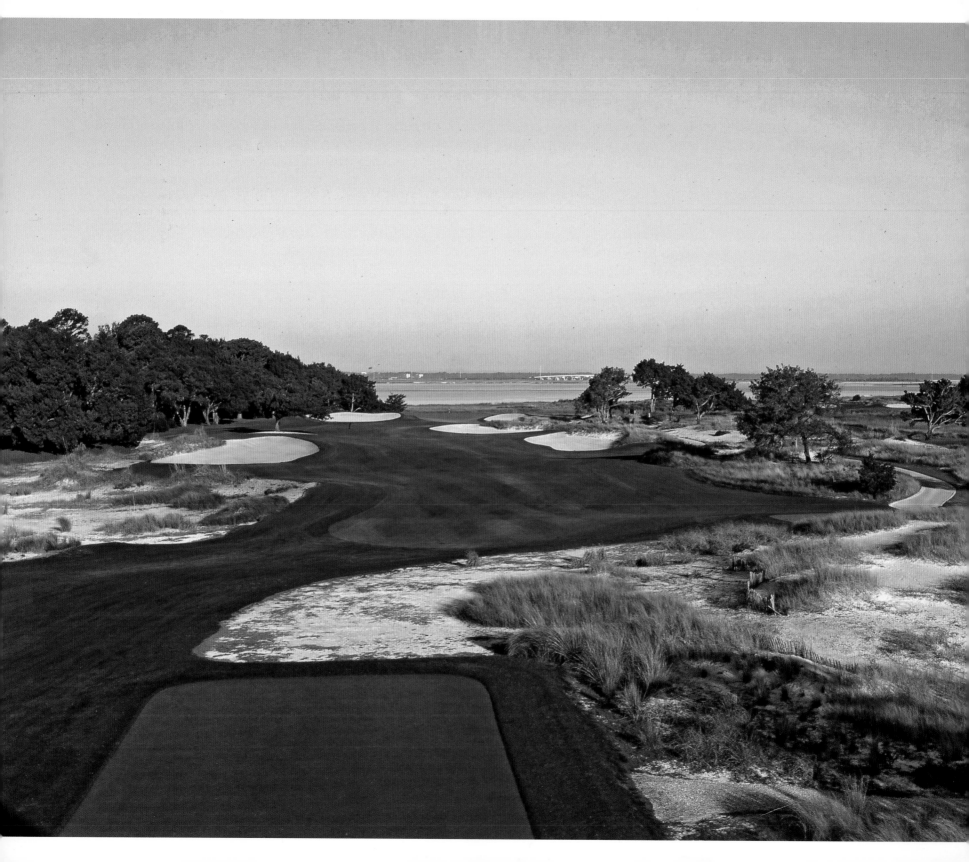

If Jones had retired at the end of 1929, he would have been forever remembered as one of the best to ever play golf. He had won the U.S. Open in 1923, 1926 and 1929 and finished runner-up four times. Jones captured four U.S. Amateur titles in 1924, 1925, 1927 and 1928. He played on four U.S. Walker Cup teams in 1922, 1924, 1926 and 1928. He also served as the playing captain of the 1928 squad. He won the British Open in 1926 and 1927. His image was on the cover of *Time* magazine. In 1927, he and O.B. Keeler collaborated on an autobiography of his career to that point. Despite all these accomplishments, they seemed a mere prelude to his record in 1930.

While Jones was flourishing, the women's game began to develop in Georgia. What became the Georgia Women's Golf Association (GWGA) was founded in October 1929. That month, an invitational tournament held at Radium Springs Country Club (now Radium Country Club), opened just two years earlier, featured twenty female golfers from all over the state. Helen Lowndes won the event, previously

winning the Women's Southern Amateur Championship in 1922 and 1924 and the Atlanta Women's Golf Association Championship in 1922, 1923, 1925 and 1926. Seeing the potential for a statewide organization to support women's golf, a meeting was held on October 29, 1929, when Eleanor Keeler was elected president of the group, a position to which she was elected five more times. She was the wife of O.B. Keeler, the newspaper chronicler of Bobby Jones's career. She served as managing editor of *Southern Golf* magazine and wrote golf articles for many newspapers.

Another participant in the 1929 tourney was Margaret Maddox, one of the best players of her era. She won the Atlanta City Tournament in 1928, 1929, 1930 and 1931. She won the Atlanta Women's Golf Association Championship four years in a row, from 1928 through 1931, and won the GWGA Championship in 1931 and 1932. Among other accomplishments, she qualified for the U.S. Women's Amateur five times and won the 1929 Southern Women's Amateur Championship.

The number of golf courses increased throughout Georgia in the 1920s. The best course designers came to the state, and in many cases, their creations still challenge today's golfers. Foremost among these designers was Donald Ross. According to Jack Nicklaus, "His stamp as an architect was naturalness." Open-front greens allowing a run-up approach shot, a layout following the natural contours of the land, shallow bunkers and greens whose surfaces sit perched above their surrounds are some of the typical attributes of a Ross design, although not present at every course where he worked.

Born in 1871, Ross enjoyed success as a competitor in golf, winning three North and South Opens (1903, 1905 and 1906), finishing fifth in the 1903 U.S. Open and in the top ten two other times and placing eighth in the 1910 British Open. Originally from Dornoch, Scotland, in 1900 Ross was appointed the golf professional at the Pinehurst Resort in North Carolina, where he began his course design career and eventually designed four courses. It was acclaim for his designs at Pinehurst that brought him recognition as America's premier golf course architect by

The Radium Springs clubhouse in its early years.

Opposite: Sea Island.

MARGARET FITZHUGH BROWNE 1928

Bobby Jones in an oil painting from 1928 that was featured in an exhibition on the art of golf at the High Museum in Atlanta in 2012.

1912. Among Ross's most famous designs are Holston Hills (Knoxville), Pinehurst #2 Oak Hill (Rochester, New York), Oakland Hills (Detroit, Michigan) and Seminole (North Palm Beach, Florida). He designed or renovated around six hundred courses during his prolific career as a golf course architect.

Ross significantly influenced golf course design in Georgia, creating some of the best courses as the game grew in popularity across the state from 1910 through 1930. In 1914, he renovated East Lake's #1 course. Several courses designed by Ross in Georgia no longer exist, including a municipal course in Gainesville that opened in 1920. Nor do his designs at Bacon Park Golf Course #2 outside Savannah (although some holes of the #1 course still exist as part of an eighteen there), East Lake's #2 course (though the nine holes of the Charlie Yates course now occupy that same plot of land) and Walthour Golf Club in Savannah.

During the 1920s, Ross designed another nine courses in Georgia. These include Athens Country Club (1926), Augusta Country Club (1927), Bacon Park #1 (1926), Brunswick Country Club (nine holes, 1938), Country Club of Columbus (1925), Forest Hills Golf Club

(1926), Highland Country Club (nine, 1922), Roosevelt Memorial Golf Course (designed eighteen but only nine were finished, 1926), Savannah Golf Club (1927), General Oglethorpe Hotel in Savannah (1929, now known as Wilmington Island Club) and Washington Wilkes Country Club (nine, 1925).

The Wilmington Island Club served as the golf resource for a Sheraton Hotel across the street for many years but eventually was purchased by Mike Foster. A restoration project brought back to the course many of the Ross features, although the routing has changed over the years.

Among the players who learned the game at Wilmington Island is Hollis Stacy, winner of the U.S. Women's Open three times and a top player on the LPGA Tour for two decades. Her sister Martha won many amateur events. Their mother, Tillie Stacy, a longtime club member, was a primary organizer on behalf of the club in hosting the U.S. Senior Women's Amateur Championship. Another LPGA Tour player, Dale Eggling, grew up in a home overlooking one of the course's golf holes, and she started in golf at the club. Among the men's professionals, Gene Sauers, Jim Ferree and Tim O'Neill, who also won a State Amateur Championship, all played the course in their early days.

The course has hosted many GSGA events. Allen Doyle won the State Amateur Championship at the club in 1979, as did Peter Persons in 1984. Several Four Ball Championships have been hosted by the club, as well as the GSGA Senior Championship and the Georgia State Open.

Many other talented architects did work in Georgia prior to 1930. Tom Bendelow, who was involved with over four hundred projects in his career, was the person who originally laid out seven holes around 1905 at what is now East Lake Golf Club, adding eleven over the next several years to form eighteen—originally the Atlanta Athletic Club's first course. The East Lake course as it is routed today and its character was influenced more by Donald Ross's work in 1915, with a further renovation by him in 1925. The current design was done by Rees Jones in 1994.

In Atlanta, two of the city's first courses were done by Herbert Barker, an Englishman who came to America in 1908: the Capital City Club at Brookhaven (1911) and Druid Hills Country Club (1912). John Van Kleek worked in the 1920s on Glen Arven in Thomasville and Radium Country Club in Albany. Seth Raynor and Charles Banks did Fairyland, now known as Lookout Mountain, in a suburb of Chattanooga in 1925. The course is actually in Georgia but belongs to the Tennessee Golf Association.

Jones opened 1930 by finishing second at the Savannah Open on the course designed by Donald Ross and then won the Southeastern Open at Forest Hills in Augusta with a thirteen-shot victory margin. For a variety of reasons, he knew that his days of competitive golf were drawing to an end. The stock market crash of late 1929 foretold difficult economic times ahead. Now Jones had a family to support, and professional golf was not a viable career option at that time, neither because of the limited financial rewards nor because of the role of professional golfer that Jones saw as being a hired hand at a golf club. It was on his career as a lawyer where he wanted to focus his attention.

In 1930, Jones had specific goals in mind, goals that began to develop as early as 1926 after his disappointing loss in the British Amateur. He knew that the Walker Cup match would be held in England in 1930. As a team member, his travel expenses would be covered by the USGA. The British Amateur was to be held on the Old Course at St. Andrews that year. It was the only significant title that Jones had not won, to be played on what had become his favorite golf course. He entered 1930 with the private ambition of winning all four national open championships of Britain and America in the same year, telling only his wife, his father and O.B. Keeler about his goal. It had never been done before, but no other golfer had equaled Jones's accomplishments to that point.

He left in early May for an extended trip to England that would allow him to participate in the Walker Cup Matches, the British Amateur and the British Open. The U.S. team defeated the team from Great Britain by ten to two, with Jones

The Donald Ross Society

The Donald Ross Society ably states it mission:

Founded in 1989 to recognize and safeguard the integrity of courses from the Golden Era of Golf Course Architecture, the Society's particular focus is the work by Donald J. Ross & Associates of Pinehurst, North Carolina before 1948. We believe that the golf courses designed by Ross are works-of-art that merit close care and meticulous preservation. When renovation work is needed, we believe that—wherever possible—the course should maintain its original look, shape, and playing character; and when accommodations are needed for the modern game, they should be consistent with the original design intent. We, therefore urge clubs to seek out those architects, shapers, consultants and superintendents in the industry who endeavor to preserve these traditions, and that are comfortable with the basic strategies outlined in our Restoration Guidelines, wherein we distill the wisdom of countless restoration successes and provide a blueprint for clubs interested in recapturing their Donald Ross design integrity.

The members of the Ross Society regularly organize trips to play golf at clubs featuring his course designs. In March 2009, more than twenty of the society's members came to Georgia to play at Highland Country Club, Roosevelt Memorial and East Lake. The outing's organizer, Derek Dobbs, is a member at the Atlanta Athletic Club, as well as the R&A in Scotland and other clubs. Wayne Aaron, one of the participants on the journey and a noted expert on golf collectibles, is a member of Cherokee Town &

Donald Ross.

Country Club in Atlanta and other clubs. For information about joining, visit www.donaldrosssociety.org.

Jones with the four trophies he won during his Grand Slam.

contributing to the victory. In winning the British Amateur in late May, Jones defeated eight opponents in separate matches at the Old Course in St. Andrews, Scotland. When Jones found O.B. Keeler among the throng of celebrants near the eighteenth green after the match, he told him, "O.B., honestly, I don't care what happens now. I'd rather have won this tournament than anything else in golf. I'm satisfied."

But he wasn't finished in his quest. In late June, at Royal Liverpool Golf Club in Hoylake, England, Jones won the British Open by a two-shot margin over Macdonald Smith and Leo Diegel. Keeler visited Jones while he waited in the clubhouse for the other golfers to finish their rounds and bring the championship to a close. Having witnessed the toll competitive golf was taking on Jones, Keeler asked him

The Beginning of a Triumphant 1930

Bobby Jones was not in great condition in January 1930. To prepare himself for the first leg of what would become the Grand Slam, Jones entered two regional events in the spring. This was an important decision, as he usually played an average of six tournaments a year. He strongly believed, though, that to capture all four majors, he must expand that schedule. He finished second at the Savannah Open, played at the Savannah Golf Club, one stroke behind Horton Smith, who would go on to win the first Masters in 1934. Unable to share in the $3,000 purse, Jones was given a twelve-gauge, double-barreled shotgun as the low amateur. A few weeks after he turned twenty-eight, from March 31 to April 1, Jones easily won the Southeastern Open, played at Augusta Country Club and over the Forrest Hills–Ricker course, with a thirteen-shot victory margin over Horton Smith. Watching him play, Bobby Cruickshank, who was twenty-nine strokes behind Jones, said to O.B. Keeler, "Bob is just too good. His play in this tournament is the finest thing I have ever seen, and do you want a prediction? Here's one. He's going to win the British Amateur and British Open, and then he's coming back here to win the National Open and National Amateur. They'll never stop him this year." Betting on his prediction, Cruickshank wagered $500 with a bookmaker in Great Britain and eventually won $60,000. This was the most money a professional golfer earned in a year having anything to do with golf until Byron Nelson earned more than $60,000 in tournament winnings in 1945. Jones would later say of the Southeastern Open, "That's where I played my finest golf of 1930."

FIFTEEN CENTS September 22, 1930

TIME

The Weekly Newsmagazine

ROBERT TYRE JONES JR.
His only peer was Percy.
(See Sport)

Volume XVI Number 12

Circulation Office, 350 East 22nd Street, Chicago. (Reg. U. S. Pat. Off.) Editorial and Advertising Offices, 205 East 42nd Street, New York.

Jones on the *Time* magazine cover in 1930.

when he might quit "this sort of foolishness." Jones replied, "Pretty soon, I think—and hope. There's no game worth these last three days." When he returned to New York, he was given a ticker tape parade; this was the second time he was so honored, the first being in 1926. A dinner for Jones held in New York attracted four hundred attendees, many of whom had come from Atlanta to see the ticker tape parade and join in the festivities.

Next came the U.S. Open at Interlachen Country Club in Minneapolis in July. Once again, Jones prevailed by two shots, this time over Macdonald Smith for the victory. At the U.S. Open, it was "Old Man Weather" who provided the biggest challenges. As Jones waited to tee off one day, a spectator asked him if he was aware that the temperature was 101 degrees in the shade. Jones replied, "Well, it's a good thing we don't have to play in the shade, isn't it?"

By the time of the U.S. Amateur in September at Merion, there was intense interest internationally about whether Jones could complete an unprecedented sweep of the major events of the time that he could enter (the PGA Championship, started in 1916, was for professional golfers only). At the U.S. Amateur, Jones put a resounding exclamation point after his title of champion. In all of his matches, Jones was never down to any opponent. In the semifinal, Jones defeated Jess Sweetser 9 and 8, and in the final, he defeated Eugene Houmans 8 and 7. The win at Merion created a nice symmetry to his competitive career—in 1916, he had first played in a national championship at Merion. In 1930, on a variety of golf courses, halfway around the world from one another, over different terrain, in varying weather conditions and against the best players in the game, Jones had triumphed dramatically. The feat, first described as the "Grand Slam" by sportswriter Grantland Rice, still stands as among the most remarkable not only in golf but also in all sports.

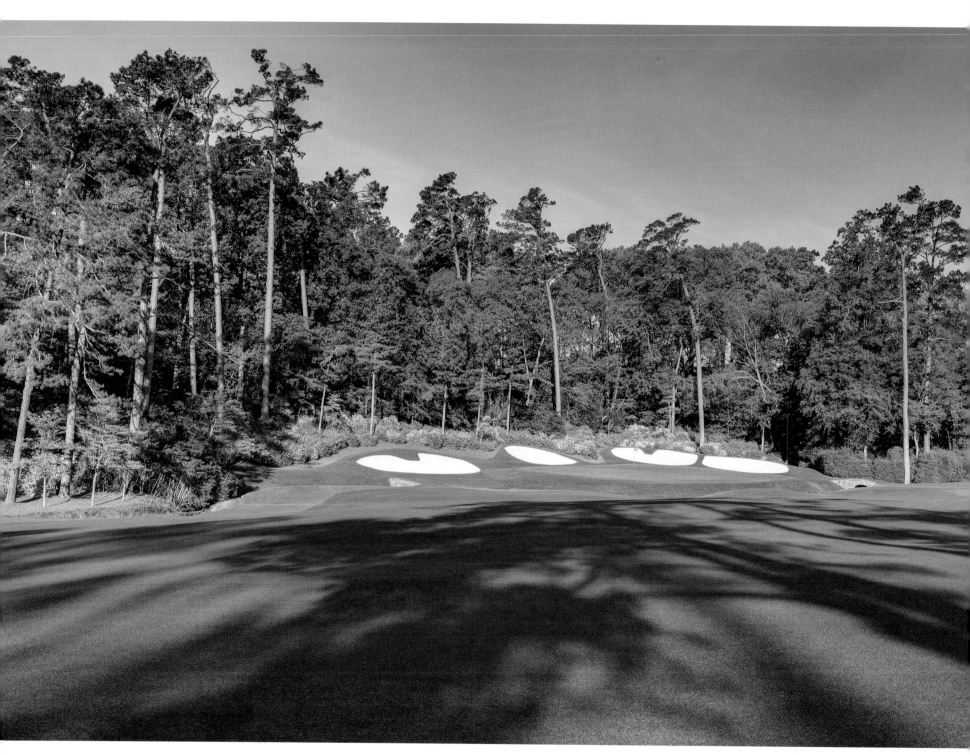

Augusta National Golf Club #13.

A NEW GENERATION

1931–1945

The retirement of Bobby Jones at the end of his triumphant year of 1930 in one sense did not have a significant impact on golf in Georgia. For most of the seven years prior to his retirement, Jones had been a part-time golfer, occasionally participating in exhibitions and ceremonial rounds for golf course openings around the state. He focused most of his competitive activity on national championships, playing in the State Amateur only in 1916 and 1920.

Contributing to his decision to retire was the opportunity to participate in a series of golf instruction films that could end his amateur golfer status since the USGA might consider golf instruction on film to be the equivalent of golf instruction on a lesson tee, thus making Jones a professional. He might have retired regardless because he wanted to focus on his law practice and supporting his family, but the lucrative terms of the film opportunity made it an easier decision. A little over six months after closing out the Grand Slam at Merion in September, in March 1931 Jones began the twelve short films titled *How I Play Golf* in Hollywood. Many Hollywood stars participated, including W.C. Fields, Loretta Young, Walter Huston and Harold Lloyd. The films are available today on DVD.

That year, Margaret Maddox won the Georgia Women's Championship at Sea Island Golf Club on St. Simons Island. She repeated the next year and then won again in 1938. Maddox won the Atlanta City Tournament in 1928, 1929, 1930 and 1931. She won the Southern Women's Amateur Championship in 1929 and qualified for the U.S. Women's Amateur five times.

Another Georgia prodigy surfaced in 1933: Mary Dorothy "Dot" Kirby, born on January 15, 1920. At the age of thirteen, Dot Kirby's victory at the 1933 Georgia Women's Amateur Championship made her the youngest female golfer to ever win a state championship, the first of her six, her last coming twenty years later, in 1953. She won the 1937 Southern Women's Amateur, and she defeated both amateurs and professionals in winning back-to-back National Titleholders Championships in 1941–42, finishing the 1941 event sixteen strokes ahead of runner-up Helen Sigel. In 1943, she won the North and South Women's Amateur Golf Championship at Pinehurst.

One year after winning the GWGA championship, Kirby played in her first United States Women's Amateur Golf Championship in 1934 at age fourteen, equaling Bobby Jones's

Dot Kirby.

age when he participated in his first U.S. Amateur. She was the runner-up in the U.S. Women's Amateur to Betty Jameson in 1939 and to Louise Suggs in 1947 and then won the event in 1951. She was a member of four U.S. Curtis Cup teams (1948, 1950, 1952 and 1954).

In the summer of 1931, Charlie Yates Sr., born in 1913, of Atlanta won the State Amateur Championship conducted at Sea Island Golf Club on St. Simons Island on the Georgia coast. Charlie would repeat as champion when the event was held at Capital City Club the following year. He won the 1934 NCAA individual title and the Western Amateur in 1935. Charlie's crowning achievement came in 1938, when, at the age of twenty-four, he won the British Amateur at Royal Troon. He also competed on the U.S. Walker Cup teams of 1936 and 1938, the latter match being played at the Old Course, St. Andrews. When asked to give a speech after the trophy presentation, which went to the Great Britain team that year, Yates announced that he would rather sing a song for the occasion. He called on Gordon Peters to join him in a song that Peters had taught him during the Walker Cup matches two years earlier at Pine Valley in the United States. The song, a traditional Scottish tune called "A Wee Deoch and Doris," entranced the crowd gathered, some of whom joined him in singing:

There's a good auld Scottish custom,
It is one o'oor best traits,
A custom we maun cairry oot,
For Auld Time's Sake.

Jist a Wee Deoch and Doris
Jist a wee yin that's a'
Jist a Wee Deoch and Doris
Afore we gang awa'

There's a wee wifey waitin'
In a wee butt and ben,
And if you can say,
"It's been a braw bricht moonlicht night,"
Ye're a' richt, ye ken.

The only other Georgian to win the British Amateur up until this time was Bobby Jones, eight years earlier as part of the Grand Slam. In addition, Charlie served as Walker Cup team captain in 1953 and competed in nine U.S. Amateur Championships. In 1985, he was named the honorary captain of the Walker Cup team. He was elected president of East Lake Golf Club in 1995, when the club was renovated by Tom Cousins. In 1980, he was awarded by the USGA the most prestigious honor in golf: the Bob Jones Award.

Eight years after Charlie first won the State Amateur, his younger brother, P. Dan Yates, won the Amateur when it returned to Sea Island. Born in 1918, Dan played on the Georgia Tech golf team from 1938 to 1941, serving as captain for three years. Dan followed well in his brother's footsteps. Dan won the Dogwood Invitational; the Atlanta City Championship; the Durham, North Carolina Invitational; and, during 1945, the Asheville City Amateur, the Country Club of Asheville Invitational and the Biltmore Forest Country Club Invitational.

Charlie Yates.

Charlie Yates and the trophy for the 1938 British Amateur.

P. Dan's son Danny inherited Dan's love for the game and obviously some of his talent. Born in 1950, Danny won the 1970 Spirit of America and played on the 1971 and 1972 University of Georgia SEC Championship teams. In 1971, he made the cut at the U.S. Open. He has won the Southern Amateur, the 1992 U.S. Mid-Amateur and the Georgia State Amateur three times, as well as the Georgia State Mid-Amateur three times. He was a member of the 1988 U.S. World Amateur Team and the 1989 and 1993 Walker Cup teams and captained the 1999 and 2001 Walker Cup teams. Because of his amateur accomplishments, Danny played in the 1989 and 1993 Masters Tournaments.

In recognition of these contributions to golf by the entire Yates family, the Georgia State Golf Foundation named its program that benefits employees of golf clubs or their dependents the Yates Scholarship. Now in its twenty-fifth year, the program has assisted 310 scholars, distributing more than $1 million to support their education.

George Sargent became the head professional at the Atlanta Athletic Club in 1932, with his hiring being heavily influenced by Bobby Jones. George served the club for fifteen years. He had accomplished a remarkable career as a competitive golfer before coming to the Atlanta Athletic Club. George won the 1909 U.S. Open at Englewood Golf Club in New Jersey. He made the cut in thirteen of the sixteen U.S.

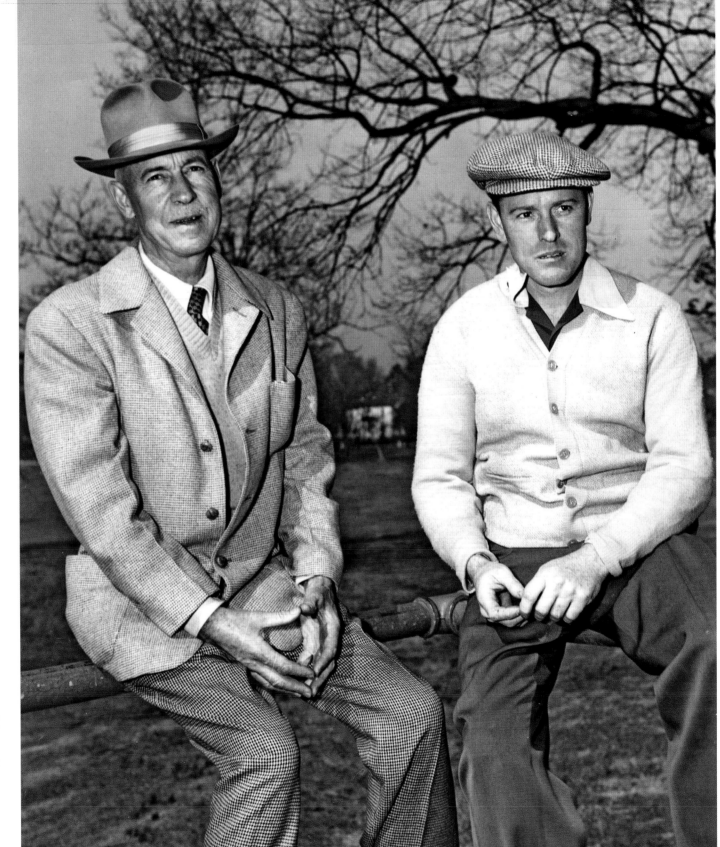

George and
Harold Sargent,
part of a family
presence at
Atlanta Athletic
Club for over
fifty years.

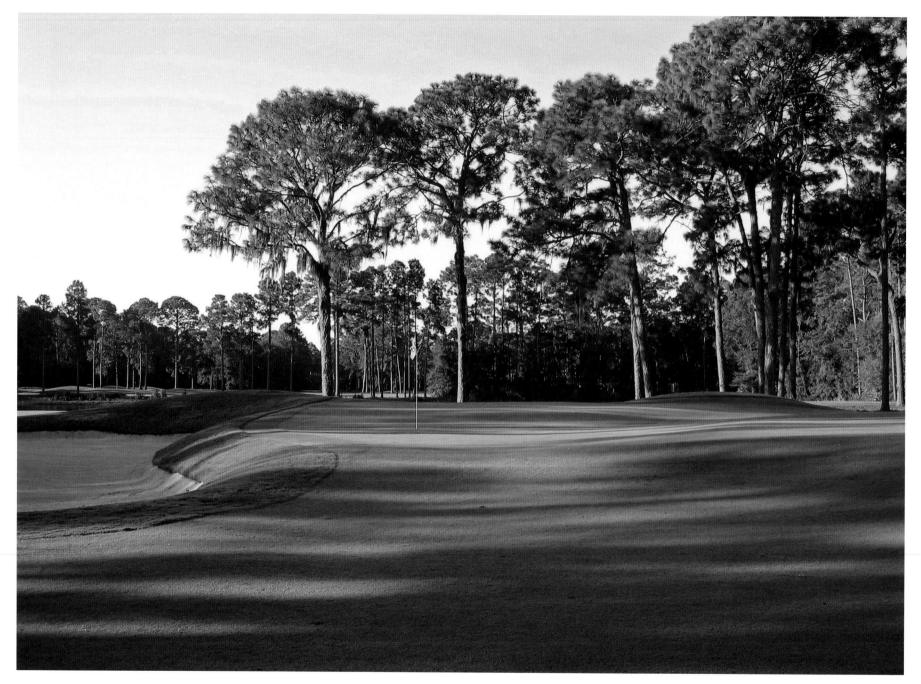

Brunswick Country Club.

Opens for which he qualified and finished in the top ten six times. He also won the 1912 Canadian Open. George became a member of the U.S. PGA at its inception in 1916 and served as president for five years. George started a Sargent family presence at the Athletic Club that was to last for more than fifty years.

George's son Harold Sargent succeeded him as head professional at the Athletic Club in 1947, and then when Harold became president of the PGA (1958–60), they became the only father-son combination to have held the post in PGA history going back to 1916. Harold's stature within the PGA influenced the Ryder Cup matches being held at the Athletic Club in 1963.

Harold worked at the Atlanta Athletic Club for a total of forty-five years, fifteen of which he served as his father's assistant. As the national chairman of the Professional Golfers Teaching Committee from 1951 to 1957, Harold inaugurated the PGA's teaching manual, and he was the longest-serving member of the rules committee for The Masters Tournament.

Extending the family connection to the Athletic Club even further, Harold's brother, Jack Sargent, became head professional at the club in 1977 and continued there until 1985. Jack became known as one of the world's premier officials of the rules of golf. He officiated at the Players Championship for eleven years and at the Ryder Cup for three events.

Billy McWilliams won his first State Amateur in 1933. Born in Rome in 1912, he again won in 1934. McWilliams sustained more than sixty years of participation as a successful amateur. Several times he qualified for the U.S. Amateur. Continuing his high level of competitiveness, he played in the Georgia Amateur at the age of seventy-eight and again at the age of eighty.

In 1934, Brunswick Country Club moved to its current location and began operation as a nine-hole facility with sand greens, designed by Cleve Lewis. The course construction work was done by the Works Progress Administration, a federal agency created during the Depression. The USGA's annual *Golf*

Guide lists the origins of Brunswick Country Club as dating back to 1899, when the area's first course opened for play. Located just south of downtown Brunswick, the golf course had nine holes measuring 2,550 yards with sand greens.

In 1920, the club had been officially chartered. In 1934, the club was relocated north from Brunswick to its current site on Highway 17, featuring nine holes. In 1938, the club hired Donald Ross to design the back nine. Later that year, Ross returned for a site visit and was pleased with the work being done. It was during this visit that Ross provided drawings to redesign the existing front-nine greens. On Labor Day 1939, all eighteen holes were officially opened for play. Over the next seventy years, the golf course gradually changed due to agronomic and maintenance practices; however, the original design remained basically untouched. In November 2006, the club began the restoration of its golf course. The work was conducted by the design group of Davis Love III, who lives not far away on Sea Island. Working from the original drawings by Ross, Love's mission was to restore what he could of the original look of the course. In some cases, when greens were taken down to the dirt, it was discovered that

Postcard of the Augusta National clubhouse from the mid-1930s.

through top dressing with sand over the years the surface of the green had risen over a foot. The golf course reopened for play in November 2007.

A Brunswick native, Ed Dudley became the first golf professional at Augusta National Golf Club (ANGC) in 1932, serving there until 1957. He also served as president of the PGA of America from 1942 to 1948. Born in Brunswick in 1901, Dudley was a fifteen-time winner on the PGA Tour, seven of them before he started at ANGC. After winning both the Los Angeles and Western Opens in 1931, Dudley had his best year in 1933, when he was a quarter finalist in the PGA Championship and won selection to the Ryder Cup team (having also played on the 1929 team). In 1937, he finished in the top ten in all four majors in one year, the first player to do so, which was not accomplished again until Arnold Palmer did it in 1960.

In 1934, the first Augusta National Invitation Tournament, eventually known as The Masters, was won by Horton Smith, who had won seventeen PGA Tour events to that point in his career. He won again in 1936 and, for the last time, on tour twice in 1941, ending with thirty total wins on tour. Until The Masters established a professional event in Georgia, the professionals had visited the state almost exclusively for exhibition matches. The issue was seasonality. The PGA Tour as it developed in the 1920s was primarily a winter tour, including stops in California, Arizona, Texas and Florida from November through March. Nearly all professionals competing in PGA Tour events were also club professionals who needed to tend to their home club responsibilities once the golf season began in early April, duties that lasted through the golf season into late September or October. Exceptions were made for club professionals to play in the U.S. Open, the PGA Championship or on the Ryder Cup team because participation in these events brought prestige to the home club.

There were other professional events in Georgia in the 1930s. Smith won the Savannah Open in 1930, Joe Turnesa won the 1924 Augusta Open, Craig Wood won the 1933 Radium Springs Open and 1938 Augusta Open, Ky Laffoon won the 1934 Atlanta Open and Henry Picard won the 1935 Atlanta Open, but these events were some of the few featuring professionals held in the state other than The Masters.

In just its second year, 1935, The Masters featured a shot that contributed to Gene Sarazen getting into a playoff that he won to take the victory. In the final round, Sarazen came to the par five fifteenth hole, then playing to 485 yards, needing to gain three shots to tie the leader at that point, Craig Wood, who was finishing his round on eighteen. After a good drive, Sarazen took out his four-wood, intending to go for the green. The shot landed at the right edge of the green and then turned left, crossed the green and went in the hole for a double eagle, a gain of three strokes. He parred in and then beat Wood in a thirty-six-hole playoff the next day, 144 to 149. Although Sarazen's shot was witnessed by only a few spectators, among them Walter Hagen and Bobby Jones, who were playing with him, the news about the rare and unusual shot went worldwide. The Masters had quickly become known for astonishing finishes

Bobby Jones with Horton Smith, who won the first Augusta National Invitational in 1934, later known as The Masters.

and great drama, which the tournament continues to provide today.

Fielding Wallace, who served as Augusta Country Club president from 1921 through 1935, played a significant role in the founding of Augusta National Golf Club. Among Georgians, Wallace was arguably the most influential figure in golf other than Bobby Jones for the first fifty years of the twentieth century. He contributed to the game at the local (serving two clubs), state (president of the GSGA) and national (president of the USGA) levels. He participated in the operations of two of the most important tournaments of his era: the Titleholders for women and The Masters for men.

Having befriended Jones during his many visits to Augusta Country Club during the 1920s (Jones's bride, Mary Malone, hailed from Augusta), Wallace and Alfred Bourne were chosen to be founding members of Augusta National Golf Club, built on land at Fruitland Nursery adjacent to Augusta Country Club. In fact, Augusta Country Club allowed Augusta National to purchase some of its land in order to create the twelfth green and thirteenth tee box at Augusta National.

Born in 1879, Wallace became president of the Georgia State Golf Association from 1936 to 1945. Wallace was named to the executive committee of the USGA in 1939, serving through 1944; named vice-president from 1945 to 1947; and became president for 1948 and 1949, the first president of the USGA from the South.

Wallace also served on the Women's Titleholders Golf Association Championship committee. First played in 1937, Patty Berg was the champion, repeating in 1938 and 1939 and going on to win four more times. The event was one of the majors for the female professionals of the era, with winners including Louise Suggs, Babe Zaharias, Peggy Kirk Bell, Mickey Wright and Kathy Whitworth. It was last held at Augusta Country Club on a regular basis until 1966 and then once more in 1972 in Southern Pines, North Carolina.

Jones, Wallace, Clifford Roberts and others involved with Augusta National and the operation of the tournament created what quickly became one of the most prestigious events annually, considered eventually as one of the majors in golf, among the four most important events to win. Byron Nelson won The Masters in 1937, followed by Henry Picard in 1938. Picard already had fifteen wins on tour prior to 1938, but Nelson was just establishing his reputation when he won, having only two previous tour victories. Ralph Guldahl, who finished second in both 1937 and 1938, won in 1939. Jimmy Demaret made his Masters victory in 1940 his sixth win on the PGA Tour that year. Craig Wood, runner-up in 1934 and 1935, won The Masters in 1941.

Two friends who had met in the caddie yard of a course in Fort Worth, Texas, at age nine in 1921 faced each other in a playoff for the 1942 Masters. Byron Nelson edged out Ben Hogan by one shot, 69 to 70. After a slow start as a professional golfer in the early 1930s, Hogan had improved to become the leading money winner on tour in 1940, 1941 and 1942. After the 1942 Masters, the tournament shut down for the next three years due to World War II, which the United States entered after the bombing of Pearl Harbor on December 7, 1941.

The Thomasville Open at Glen Arven would also host PGA Tour events in the 1930s, attracting the best golfers of the day. The winners included Johnny Revolta (1936), one year after he won the PGA Championship and finished as the leading money winner on the PGA Tour; Dick Metz (1937), two years before participating on the U.S. Ryder Cup team; Byron Nelson (1938), one year after he won The Masters; Henry Picard (1939), one year after he won The Masters; Lloyd Mangrum (1940), who won the 1946 U.S. Open; and Harold "Jug" McSpaden (1941), who set the PGA Tour record of thirteen second-place finishes in 1945, the year Byron Nelson won eighteen tournaments.

Athens Country Club, which opened in 1924, hosted its first Southern Intercollegiate Golf Tournament in 1935, still an important event in collegiate golf. Club member B.J. Clemence recalled seeing the Wake Forest team arriving at the club for the event in the early 1950s in several Cadillacs, an indication of the importance of golf at the school even then. When it opened, the course measured 6,554 yards, but it

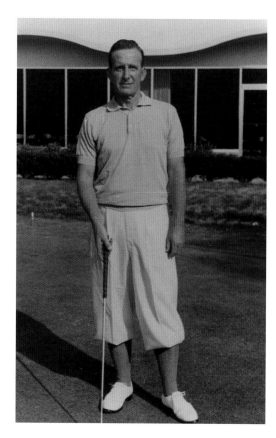

Frank Mulherin.

played to a par of 73, maybe because of the 103 sand bunkers sculpted for the course by designer Donald Ross. Former head professional Ed Hoard was named as the Georgia PGA Section PGA Professional of the Year in 1983 and 1984. Hoard was known as a national expert on the *Rules of Golf* and officiated at many PGA Championships, Ryder Cups and other significant tournaments.

Opened in Atlanta in 1937, the North Fulton Municipal Golf Course at Chastain Park was designed by one of the most remarkable figures in the history of American golf. Born in 1884 in Chicago, Illinois, H. Chandler Egan served as captain of the golf team while at Harvard, winning the NCAA individual title in 1902. In 1904 and 1905, Egan won back-to-back U.S. Amateurs played at Baltusrol Golf Club in New Jersey and Chicago Golf Club, respectively. He won an individual silver medal at the 1904 Summer Olympics, the last time golf was featured. The U.S. team did win the golf gold medal at that Olympics. Following college, Egan moved to Oregon, winning the Pacific Northwest Amateur five times, in 1915, 1920, 1923, 1925 and 1932. He played on two winning U.S. Walker Cup teams (1930 and 1934). As early as the 1910s, Egan began doing golf course design, with many courses in Oregon and Washington credited to him. In 1929, Alister MacKenzie had

Egan join him to renovate Pebble Beach Golf Links for the 1929 U.S. Amateur, in which Egan played and reached the semifinals. Egan also assisted MacKenzie on Sharp Park Golf Course in Pacifica, California (1932), one of MacKenzie's few municipal courses. It must have been Jones's and Mackenzie's familiarity with Egan that facilitated him coming to Atlanta to design North Fulton. The course hosted PGA Tour events in 1949 and 1950, with Jimmy Demaret winning at North Fulton in 1950 one week after he won The Masters for the third time (1940 and 1947). Another addition to Atlanta's municipal courses in the 1930s was the Bobby Jones Golf Club in the Buckhead section of the city. The eighteen-hole facility plays to 6,455 yards from the longest tees for a par of 71. It opened in 1934.

Few golf courses were built during the troubled economic era of the Great Depression. Fortunately, those who loved golf had an advocate of the game in the White House. Franklin D. Roosevelt had been an avid golfer prior to contracting polio in 1921.

Early in his career, as assistant secretary of the navy, FDR had played golf almost every day, including on Sundays at Chevy Chase, where he was occasionally paired with Senator Warren G. Harding of Ohio. As president, FDR directed that more than 350 public golf courses be built by federal programs. College Park Municipal, which opened during the 1930s, was one of the courses built by the Works Progress Administration (WPA), as were Bobby Jones Golf Course, Forsyth Golf Club (initially only nine holes, with another nine added in 1992), Bowden Golf Course in Macon and Rabun County Golf Club in Clayton.

Charles Harper won the first Valdosta Invitational in 1940. The next year, the tournament was renamed the Jack Oliver Invitational. The event continued through the war years, with Dynamite Goodloe winning in 1943 and 1944.

The Oliver family has been in the forefront of golf's competitors, administrators and supporters in Georgia for more than eighty years. Their involvement extends back to the establishment of the Georgia State Golf Association in 1924, when Jack Oliver of Valdosta was a founding director

Jack Oliver.

THE STYMIE

This scorecard from the early days of the Bobby Jones Golf Course provides a six-inch measurement to determine stymies, a rule in golf that ended in 1952. If a player's ball blocked the path of another player's ball on the green but the balls were not within six inches of each other, then the ball blocking the path to the hole was not lifted, requiring a shot over or around the ball in the path to the hole. In singles match play, when one player's ball blocked the path of another player's ball on the green but was not within six inches, the obstructing player's ball was not lifted. In 1938, the USGA tried a two-year trial in which

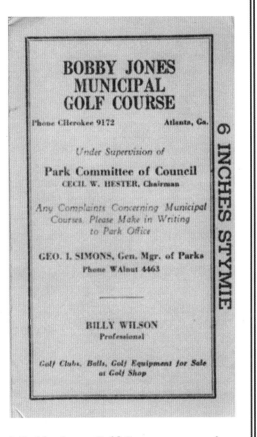

A Bobby Jones Golf Course scorecard with stymie measurement.

an obstructing ball within six inches of the hole could be moved regardless of the distance between the balls, a rule that lasted from 1941 to 1952—thus the need in that era for the measuring device.

as the organization officially incorporated. Billy Oliver of Macon, Jack's grandson, has continued the family's support of the organization, and he is still active in the GSGA.

Born Warren Maxwell Oliver, Jack Oliver earned his nickname on a hunting trip. According to Billy, who while growing up was told many stories about his grandfather, Jack was called a "crackerjack shot," and the Jack portion stayed with him throughout his life.

Jack not only made many contributions to golf himself, but also his sons Maxwell Jr., Billy and John all served as captains of the University of Georgia golf team during their times at the school. Maxwell Jr. played on UGA's golf team and served as team captain in 1927. Maxwell Jr. also played on the football team at UGA, breaking his leg in the Alabama game in 1923, which led to him switching to golf. He won the Piney Woods Golf Tournament at Glen Arven in 1929.

In 1928, Jack's son William W. "Billy" Oliver served as captain of the UGA golf team. Billy won the Piney Woods four times, beginning in 1925. In 1929, John won the Georgia State Amateur Championship at Radium Springs Golf Club and then captained the UGA golf team in 1930. In 1940, John won the Piney Woods.

Carrying the family tradition into the next generation, John's son Jack Oliver Jr., as a sophomore at Valdosta High School, won the state high school crown in 1959. He finished second in the state amateur in 1965. Jack Jr. also won the SEC championship in his sophomore year at UGA in 1963. Playing in the Jack Oliver Invitational in 1964, Jack Jr. shot a 64. He won the event in 1980 and 1983.

The son of Billy Oliver, William W. Oliver of Macon (Jack Jr.'s cousin), also known as Billy, played competitive golf through high school and in his freshman year at UGA. Billy's teammate from high school, Bunky Henry, went on to attain First Team All-American honors while playing for Georgia Tech in 1964, the same year he won the State Amateur Championship.

Pete Cox won the Jack Oliver Invitational twice, two of his 150 tournament wins that earned him induction into the Georgia Golf Hall of Fame. In 1963, he won the Georgia State Amateur Championship and, in 1986, the Georgia Senior Open Championship. Pete has been very instrumental in the development of junior golf in the state of Georgia. In 1973, he helped organize the Georgia Junior Sectional Tournament Program. He served as chairman of this program for sixteen years.

The first Dogwood Invitational, held on April 25, 26 and 27, 1941, validated Druid Hills Golf Club as a challenging venue for tournaments. Tommy Barnes, the inaugural event's champion, won with a score of 292, four over par, the same year he won the State Amateur. This was the first of what would be a total of five Dogwood Invitational wins for Barnes.

Dan Yates Sr. won the event the next year. After a suspension from 1943 to 1945 for World War II, the Dogwood resumed in 1946 with winner Gene Dahlbender Jr. displaying the talent that led to seven victories in the tournament. He

P. Dan Yates being celebrated for winning the Georgia State Amateur Championship in 1939.

bettered Barnes's score in 1941 by 14 shots, coming in with a 278 total. He might have been inspired by a visit to Druid Hills by Byron Nelson and Ben Hogan for an exhibition match one month prior to the Dogwood.

The game of golf, and the sites where it was played, was dramatically changed by World War II. Members of private clubs were drafted into the armed forces, as was the staff at clubs, causing a reduction in income for clubs and difficulty in maintaining service levels. Golf equipment manufacturing was prohibited by the federal government so that the materials could be used for the war effort. Golfers could make do with the golf clubs they had used prior to the war, but the lack of golf balls became such a problem that by 1944 people were asked to locate any old golf balls they might have in storage and turn them in for reconditioning.

With manpower at a shortage, and club budgets reduced from the prewar years, golf course maintenance was reduced; some courses even filled in bunkers to eliminate the need for replacing or maintaining the sand or cut down the rough so that golf balls would not be lost in tall grass.

Across the country, golf course maintenance had to be curtailed because of a lack of staff, fewer golfers playing fewer rounds and gasoline rationing. Some clubs converted areas on their fairways or roughs to what were called victory gardens. The playing character of the courses that remained open also changed. Narrower fairways meant less mowing. Sand bunkers were removed from some courses or allowed to revert to grass bunkers, especially those along the fairways.

Due to rationing of tires and gasoline, for those golfers not in the service, getting to the golf club became problematic. Even professional golf had to be curtailed due to these complications. In 1943, the PGA Tour mounted only three official events. The Masters was suspended from 1943 through 1945, the U.S. Open was not played from 1942 through 1945, the PGA Championship was cancelled in 1943 and the British Open was shelved between 1940 and 1945.

Many PGA Tour professionals entered military service, including Sam Snead; Jimmy Demaret; Ben Hogan, the top money winner on tour from 1940 to 1942; Lloyd Mangrum, who would win the first postwar U.S. Open in 1946

Byron Nelson, who won four tournaments in Georgia during his career.

Byron Nelson and Georgia

Byron Nelson counted four wins in Georgia during his career on the PGA Tour. He first played in Georgia in 1935 in an event in Atlanta and then followed that with a tie for ninth in his first appearance at The Masters. The next year, he finished tied for twelfth at The Masters. Then, later that year, a professional tournament was held in Augusta, but not at Augusta National, and Nelson finished tied for thirteenth. The PGA Tour stopped at Glen Arven in Thomasville in early 1937, and Nelson tied for fourteenth. Six weeks later, Nelson won his first Masters, earning $1,500, his biggest payday to that point. He later claimed that winning The Masters that year, only his third win on the PGA Tour, was what gave him the confidence to have success in his career, and he described it as his most important win.

When he returned to Glen Arven the following year, he won there and then finished fifth at The Masters. Showing how meager the payouts could be on the PGA Tour at the time, when Nelson finished in eighth place at another professional event in Augusta later in 1938, he earned zero dollars for his trouble. His next three visits to Thomasville resulted in finishes of tied for fourth, tied for second and tied for sixth. In The Masters for those years, he finished seventh, third and second. He liked playing in The Masters, later saying in his autobiography, *How I Played the Game*, "In the early days of The Masters, it was the most enjoyable tournament to go to in the whole country, from the players' point of view." When he won The Masters again in 1942, it was one of five victories on the PGA Tour for him that year. Three years later, when he won a PGA Tour stop in Atlanta, it was the fourth win in a record stretch of eleven consecutive wins on tour for Nelson. He liked playing golf in Georgia.

Byron Nelson and Bobby Jones walking together at The Masters.

and eventually thirty-six events in his career; Sam Byrd, who finished third at The Masters in 1941 and fourth a year later, when he also won the Greater Greensboro Open; and Johnny Bulla, runner-up in the 1939 British Open and winner of the 1941 Los Angeles Open.

The PGA Tour began to revive in 1944, with twenty-two tournaments scheduled, which paid off in war bonds, not cash. Byron Nelson won eight of the events. With The Masters on hold because of the war in 1945, the early April date of the event was open for a different tournament. The event scheduled for Atlanta from April 5 to 8 had been announced only in January, when the governing board of the Capital City Club voted its approval to serve as host club. The CCC Brookhaven course was to play to a par of 69 for the tournament, one of the few times this happened in the history of the PGA Tour.

Nelson, the favorite in the tournament, had won the most recent three PGA Tour tournaments and a total of seven for the year, but Snead also had accomplished a three-win streak and had four wins for the year, six going back to the fall of 1944. Thus far in 1945, Snead and Nelson had won eleven out of the sixteen events played.

Nelson won the Atlanta tournament with a 263, setting a new record for cumulative score in a PGA Tour event, nine shots ahead of Sam Byrd in second place. Snead finished eighteen shots behind. At the time of Nelson's win in Atlanta, the course routing ended with a difficult 246-yard, par three hole, which he managed to par only in one round out of four. When Charlie Yates, in 1995, complimented Nelson on being able to remember the hole after not having seen it in fifty years, he replied that he had three-putted on that hole to end the tournament. "I hate like the dickens to three-putt the last hole in any tournament," Nelson said. That three-putt was only a minor irritation during a year when Nelson won eleven events in a row, still a PGA record. Atlantans had witnessed history in the making. Nelson won a total of eighteen tournaments that year, combined with eight in 1944 and then six in 1946, his last year on tour before retiring. Nelson was credited for 112 official rounds during 1945, for which he averaged 68.33 per round. Over the three years from 1944 through 1946, Nelson entered seventy-five tournaments and won thirty-four times, 45 percent of the time.

Though the war was coming to an end, the national economy had not dramatically improved since the buildup in war production during 1940 and 1941. Without that stimulus, there was no guarantee that the nation might not slump back into a depression. As happened with so many Americans who came of age during the Depression, Nelson's eventual retirement from golf in 1946 to become a rancher had less to do with rejecting a sport he loved and far more to do with his desire for economic stability and security.

DON'T ASK WHAT I SHOT

1946–1960

The period from 1946 to 1960 saw rapid growth in the number of people playing golf, the number of golf courses and interest in the game, even from non-players. Rather than returning to the economic doldrums of the late 1930s, Americans began to enjoy not only better financial circumstances but also more time for recreation. Golf was a major beneficiary of these developments.

Two key figures stimulated interest in the game and its acceptance among the entire populace. In 1952, Dwight David "Ike" Eisenhower was elected President of the United States. He would play eight hundred rounds of golf while in office. He spent weeks staying on property at Augusta National and enjoying the game he loved. His appreciation of the joys of the game, however challenging, led to a promotional button of the era that read, "Don't Ask What I Shot." Because Eisenhower was so well liked by the public, his involvement in golf inspired people to try the sport who may never have previously been on a golf course.

Upon the occasion, in 1953, of Bobby Jones giving an oil painting of himself by artist Thomas E. Stephens to the USGA, President Eisenhower sent a letter to the USGA in tribute to Jones. The President wrote:

You all must be proud as I am to have Bob's portrait hanging in Golf House. Those who have been fortunate enough to know him realize that his fame as a golfer is transcended by his inestimable qualities as a human being. Bob's contribution to our great game is reflected by its deserved prominence in the field of sports. But his gifts to his friends are the warmth that comes from unselfishness, superb judgment, nobility of character, and unwavering loyalty to principle.

The other golfer who helped build the game was Arnold Palmer, who came along just at the time when television was growing its audience, and any and all programming found an audience during the era of only three major national TV networks and the occasional local station. Palmer won the U.S. Amateur in 1954, but it wasn't until he won The Masters in 1958 and 1960—the latter a year he won eight events on the

Opposite: Cherokee North Course #18.

President Eisenhower with Byron Nelson, Ben Hogan and Clifford Roberts.

PGA Tour—that he developed a following that described itself as "Arnie's Army." Palmer was handsome and athletic in build and seemingly typecast for television. He delivered excitement that previously was unknown by the fairly sedate sport of golf and made the game attractive to anyone who enjoyed competitive sports.

In Georgia, golf resumed with a strong calendar of events in the first year after the war. The first postwar Dogwood Invitational, held in 1946, was won by Gene Dahlbender Jr., the beginning of a total of seven wins in the tournament for him. Dahlbender bettered Barnes's score in 1941 by 14 shots, coming in with a 278 total. Ten of the first fifteen Dogwood Invitationals were won by the dominant duo of Barnes or Dahlbender, with Dahlbender shooting a 63 in the third round of 1948, without winning. Charlie Harrison, Vinnie Giles, Harvie Ward Jr. and Jack Penrose were some of the other early winners.

With course renovations planned for early 1973 requiring a potential postponement until an August date, the Dogwood was cancelled that year. After twenty-seven tournaments (there was another hiatus in 1968–69), the event did not return until 1994. Allen Doyle, at forty-five still one of Georgia's best amateur golfers, had won six Georgia State Amateur titles and added the Dogwood. Doyle went on to a distinguished career as a professional on the Champions Tour, being named Player of the Year in 2001.

More than a golf tournament, the Dogwood Invitational partners with external sponsors in an effort to raise funds and awareness to help junior golf succeed. The Atlanta Junior Golf Association and the Wayne Reynolds Scholarship Foundation are beneficiaries of the tournament. The Druid Hills Golf Club Foundation, which administers the Reynolds Scholarship, helps qualified junior golfers with their college tuition. Established in 1996, the Reynolds Scholarship and the Dogwood Invitational work to award deserving students a $12,000, four-year college scholarship.

Georgia's best female golfer came into her own in the late 1940s. In the foreword Ben Hogan wrote for Louise Suggs's instruction book *Par Golf for Women*, published in 1953, he said of her, "The swing she showed in 1945 was a beautiful thing—so smooth and rhythmic, so soundly joined together—she was bound to be a winner." Born in 1923, her first title was the 1940 Georgia State Women's Amateur Championship at age seventeen; she would repeat as champion two years later. She captured the Southern Women's Amateur Championship in 1941 and later repeated as champion in 1947.

Her early victories suggested that she would achieve much at the highest levels of golf. In 1946, she confirmed her promise. That year, she won the Western Amateur Championship and Western Open and successfully defended both titles the following season. She won her second of three victories in the North/South Championship (1942, 1946 and 1948), plus the Titleholders, played at Augusta Country Club in 1946, then considered a major. In 1947, she won the U.S. Women's Amateur Championship and a year later won the British Amateur Championship. She

participated on the 1948 U.S. Curtis Cup Team, the first one held after World War II.

Louise went on to achieve equally dramatic results after the creation, in 1950, of the Ladies Professional Golf Association Tour (LPGA), which she helped found. Golfers who are immediately successful on the LPGA Tour are now honored with the Louise Suggs Trophy, given annually to the recipient of the Rolex Rookie of the Year Award.

While in high school, she met Bobby Jones, and he provided her with a swing tip: "One time I asked him, 'Mr. Jones, if you had one piece of advice to give me, what would it be?' He said, 'Knock hell out of the ball—it'll come down somewhere.' So that's about the extent of it," Suggs recalled. "He said as long as your grip's good, and your position's good, and your tempo's good, and you stay over the ball, that's all that you can do. If that doesn't work, it's not going to work."

On July 8, 1948, she turned professional, winning her first U.S. Women's Open in 1949 by a margin of 14 strokes at Prince George's in Maryland. This was a tournament she was to win again in 1952.

She helped found the LPGA in 1950, finishing no lower than seventh on the money winners' list her first twelve years on tour and no lower than fourth among money winners in eleven of those twelve years. When she finished as top money winner on the LPGA Tour in 1953, she won eight of the nineteen tournaments she entered. Her last tournament

Louise Suggs.

win on the LPGA Tour was the St. Petersburg Open in 1962; this is included among fifty-eight professional victories. She served three times as LPGA president.

Although not quite the prodigy that Dot Kirby and Louis Suggs were, Mary Lena Faulk evolved to being one of the best golfers of her era. In 1946, she won the first of three consecutive Georgia Women's Amateur Matchplay Championships. In 1953, Faulk won the U.S. Women's Amateur, and then in 1954 she lost in the semifinals to Mickey Wright. She was a member of the 1954 U.S. team that defeated Great Britain to win the Curtis Cup, and in Georgia, she won the state's 1954 Medal Play Championship.

In her rookie year on the LPGA Tour in 1955, she finished second at the U.S. Women's Open. Faulk retired from the pro tour in 1965, having won ten tournaments including the Women's Western Open, which was then a Major in women's golf championships.

Suggs passed away in 2015. "I feel like the LPGA lost a parent," Commissioner Mike Whan said of her.

> But I'm extremely confident that her vision, her competitiveness and, most importantly, her spirit will be with this organization forever. Like a parent, she cared deeply for her LPGA family and took great pride in their successes. She always made time to hear my problems and challenges. Her personal guidance was priceless. Like a parent, I think she was even more proud of the LPGA players of today than she was of her own playing results.

Arnold Blum won his first State Amateur Championship in 1946. Four years later, Blum won again and then repeated the feat in 1951, 1952 and 1956. He also finished second in 1953. Not only a fine competitor, Blum also served as president of the GSGA in 1960 and 1961. Only Allen Doyle, with six victories in the State Amateur Championship (1978, 1979, 1982, 1987, 1988 and 1990), has more titles.

John B. "Sonny" Ellis won the 1946 Southern Intercollegiate Tournament. Sonny's father, Jack Ellis of Columbus, introduced his son to golf at age eight. Sonny played in his first competitive tournament at age nine and in the Georgia State Amateur Championship in 1937, at age twelve, five feet tall and weighing ninety-six pounds. By 1946, Sonny had established a significant reputation as a competitor. Sonny won the 1940 Georgia high school individual title, the 1941 Southern Prep in Chattanooga

Sonny Ellis.

and, in 1942, tournaments in Selma and Eufaula, Alabama, and in Griffin, Georgia. In 1942, he entered LSU on a golf scholarship; he was named First Team All-American in 1943 prior to entering the U.S. Navy.

In 1947, Sonny won the Colonial Invitational Amateur in Memphis. He combined with Gardner Dickinson and brothers Jay and Lionel Hebert to win the NCAA Championship in 1947 and attain runner-up the next year. After college, Sonny continued to compete in amateur golf. Sonny won club championships at three clubs during the 1950s: Capital City Club in 1958, Cherokee Town and Country Club in 1958 and 1959 and Peachtree Golf Club in 1955, 1956 and 1957. Sonny served on the board of directors of the Southern Golf Association from 1957 to 1965. He served as president of the Georgia State Golf Association in 1962 and 1963.

Radium Country Club formerly incorporated in 1947, with Frank Hedrick as president. Hedrick was an excellent player, participating in the U.S. Amateur at Oak Hill in Rochester, New York, in 1948 and the British Amateur in 1957. He continued competing in golf, at one point finishing second in a GSGA Senior State Championship. He also served on the board of directors of the GSGA.

Opened originally in 1927 as Radium Springs Golf Club, the course hosted the 1928 State Amateur Championship. The club's first head professional, Joe Kirkwood, finished third in the British Open in 1927, a year that Bobby Jones won the event. The club has hosted three State Amateurs (1929, 1949 and 1963).

Three years in the making, Peachtree Golf Club in Atlanta opened nine holes in October 1947 and the additional nine in July 1948. Bobby Jones and Dick Garlington were the prime movers behind the establishment of the club. Jones brought in Robert Trent Jones Sr. to do the course design, with considerable input from Bobby. During the club's development, Bobby Jones's battle with syringomyelia, the spinal condition that ultimately crippled him, forced him to abandon playing golf. He never played the completed course at Peachtree, but he had a critical role in the club's

foundation. Ranked among the top fifty private golf courses in the United States, Peachtree Golf Club measures 7,414 yards from the longest tees and has a slope rating of 141 and a 75.9 USGA rating. The same year Peachtree opened, 1948, the U.S. Amateur Public Links Championship, a USGA event, was played at Atlanta's North Fulton Park Golf Course. Jones served as honorary chairman of the event.

Among Peachtree's membership have been two presidents of the USGA, a president of the GSGA, Georgia State Amateur champions and many who have served golf in different capacities. Several club members have played for the U.S. team in Walker Cup competitions and served as captains. In 1989, the Walker Cup competition was hosted at Peachtree, a fitting tribute to club founder Bobby Jones, the greatest amateur golfer who ever played the game.

The 1948 U.S. Amateur was something of a high-water mark for entrants from Georgia. Held at Memphis Country Club, a Donald Ross design, the reasonable travel distance may have inspired Georgians to qualify. Out of a total of 1,220 entrants nationwide, 210 players made it to qualifying and starting in Memphis. Eleven players from Georgia made it to match play, including J. Pete Barnes from Atlanta; Bill Zimmerman, Augusta; Jack Key, Columbus; George S. Hamer, Columbus; Hobart Manley Jr., Savannah; Tommy Barnes, Atlanta; Richard Hackett, Coosa; Gene Dahlbender Jr., Atlanta; James Key, Columbus; Frank Mulherin, Augusta; and Dynamite Goodloe, Valdosta. Dahlbender made it to the semifinals in the entirely match play event.

Two years after opening for play in 1948, Sunset Hills Country Club, a design of Robert Trent Jones Sr., hosted the Ladies Invitational Golf Tournament, which included both amateurs and professionals. Patty Berg won that fifty-four-hole event played over the nine holes open at the club at that time. (The second nine were added in 1973.) Louise Suggs finished second. The next year, Suggs won the event, making an eagle on the last hole to finish one stroke ahead of Babe Zaharias. Several talented golfers have been members at Sunset Hills, including Andy McClendon, a Division II All-American at Florida Southern; Matt Street,

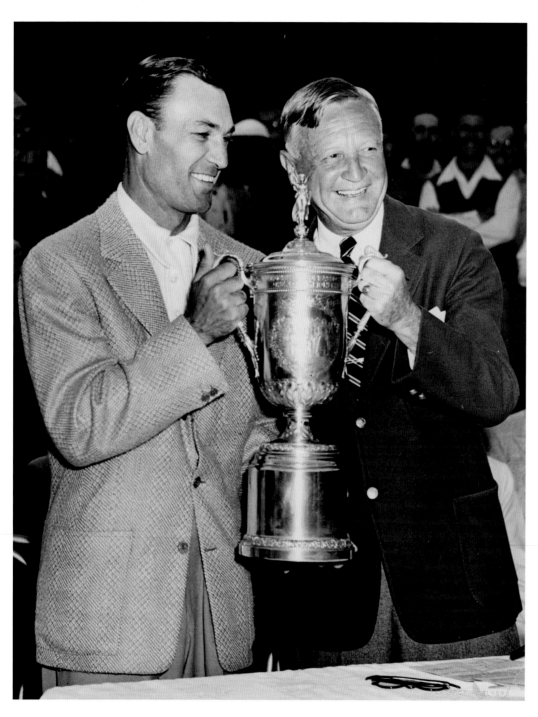

Fielding Wallace awarding Ben Hogan the winner's trophy at the 1948 U.S. Open.

who attended the University of Georgia on a golf scholarship; and Barry Harwell, who made it to the PGA Tour in the 1980s.

The low amateur in the 1950 Ladies Invitational at Sunset Hills, Beverly Hansen, had just the week before won the U.S. Amateur at the East Lake Course of the Atlanta Athletic Club. In this match play event, Hansen had to win six matches to become champion. The course was set up to play from 6,521 yards, but it played to a par of 74 for the 105 golfers.

One year after the Atlanta Athletic Club at East Lake hosted the U.S. Women's Amateur, Druid Hills hosted the U.S. Women's Open. Betsy Rawls from Austin, Texas, won the event, trailed by Louise Suggs by five strokes. The LPGA conducted the Women's Open from 1949 through 1952, and then the USGA took over the championship.

Brunswick Country Club inaugurated the Golden Isles Invitational in 1949, a tournament whose first champion was William "Dynamite" Goodloe of Valdosta. He eventually won the event another three times, and he also won the 1953 GSGA State Amateur Championship. The champions list for the Golden Isles includes the best in golf in Georgia for the past fifty years, among them Jimmy Cleveland, State Amateur five-time-champion Arnold Blum, Gene Dahlbender, Bunky Henry, Mark Army, U.S. Amateur champion Steve Melnyck, PGA Tour pros Andy Bean and Peter Persons and 1997 PGA champion Davis Love III. Mike Cook of the Sea Island Golf Club is a two-

The Wallace House at Augusta Country Club honors the contributions to the club of Fielding Wallace.

time champion, and Wally Adams, whose father, Wallace Adams, has a state park named after him, won the title once.

One of the more remarkable achievements in Georgia golf is Darien native Bill Ploeger's eleven titles for this event, the first coming in 1971, followed by back-to-back victories in 1998 and 1999, when he also won the USGA Senior Amateur Championship. A graduate of Georgia Tech, he captained the Yellow Jacket golf team and earned NCAA All-American honorable mention. He qualified for the U.S. Amateur five times and the U.S. Mid-Amateur four times. Ploeger has also won the Georgia Senior Championship four times and captured the 1999 USGA Senior Amateur. In 1999, *Golf Digest* ranked Ploeger the top senior player in the United States. That same year, he also received the GSGA's Tommy Barnes Award as the overall Player of the Year in Georgia, an honor he repeated in 2002.

Eileen Stulb, born on June 23, 1923, in Augusta, won her first GWGA Match Play Championship in 1950 and then repeated the next year. She played in the U.S. Women's Amateur seven times, the U.S. Women's Open and the USGA Senior Women's Amateur. Stulb was the local chairwoman for the 1971 U.S. Girls' Junior Championship held at Augusta Country Club.

Callaway Gardens opened in May 1952. Owned and operated by the Ida Cason Callaway Foundation, named for Cason Callaway's mother, today's Callaway Gardens spreads across fourteen thousand acres. It was Cason and his wife, Virginia, who had the vision to develop the property. The Mountain View course there, designed by Dick Wilson, hosted a PGA Tour event from 1991 to 2002. British Open champion David Duval was among the winners on the Mountain View course, as were PGA champions David Toms, Steve Elkington and Davis Love III.

The Lake View course was Callaway Gardens' original course, designed by J.B. McGovern and Dick Wilson. The course has nine water holes. Callaway Gardens has horticultural displays, including a butterfly house where a visitor can walk among the butterflies, tennis courts, fishing, water sports, fine dining and lodging.

In 1953, E. Harvie Ward won the State Amateur; that same year, he finished second in the British Amateur, and a year later he won the British Amateur. One of the best amateurs of the 1950s, Ward won consecutive U.S. Amateur titles in 1955 and 1956. Ward played on three winning Walker Cup teams (1953, 1955 and 1959), winning all six of his matches.

"Dynamite" Goodloe won the 1954 and 1955 State Amateurs. The 1957 winner, Tommy Aaron of Gainesville, repeated in 1960. Aaron lost the U.S.

Eileen Stulb.

Callaway
Gardens.

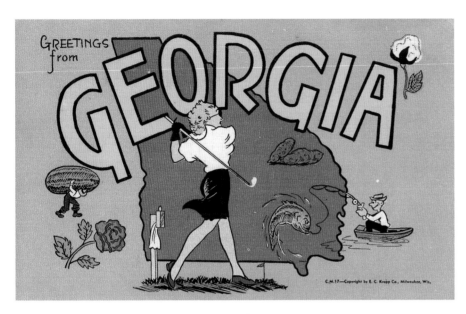

A Georgia tourism postcard from the 1950s.

Alfred "Tup" Holmes.

Amateur final to Charles Coe in 1958, was a member of the 1959 U.S. Walker Cup team and won the Western Amateur in 1960.

After Aaron turned pro in 1960, his first professional victory came at the 1969 Canadian Open, followed by the Atlanta Classic later that year. The highlight of his career was when Aaron won The Masters Tournament in 1973—his only major championship. In 2000, When Aaron made the cut at The Masters at the age of sixty-three, he broke a record previously held by Gary Player as the oldest player to make the cut.

On December 24, 1955, five African American golfers teed off at Atlanta's North Fulton Course. A decision by the U.S. Supreme Court had been necessary to allow these golfers to play a public course in Atlanta, something that had been prohibited previously. In 1951, Dr. Hamilton Holmes; his sons, Alfred "Tup" Holmes and Oliver Wendell; and Charles Bell attempted to play at Bobby Jones Golf Course but were refused the opportunity. The men organized the Atlanta Golf Committee and hired lawyer Roscoe Edwin Thomas to represent them in a suit against the city. After a series of court battles, the men finally prevailed when the U.S. Supreme Court ruled in their favor, upholding a previous decision by the Fifth District court in their favor. Atlanta mayor William B. Hartsfield ended the prohibition. In recognition of this accomplishment, in 1983, the Atlanta City Council renamed Adams Park the Alfred "Tup" Holmes Memorial Golf Course.

The 1959 State Amateur champion, Charlie Harrison, had been a top competitor in the state for fifteen years by that point. Born in 1931 in Atlanta, Harrison, at age thirteen in 1944, won the Atlanta Athletic Club's junior championship, barely a year after starting to play the game. In 1947, he won the Atlanta City Junior Amateur Championship. After this auspicious beginning to Harrison's career as a competitive golfer, he entered Georgia Tech, where he lettered in golf for four years while also participating on the swim team during his first three years at the school. In fact, Tech's four-hundred-yard freestyle relay team set a Southeastern Conference record while Harrison was on the team.

Harrison won the 1955 Southern Amateur, winning matches against Doug Sanders and Billy Joe Patton on his way to that victory. In the 1959 U.S. Amateur, Harrison made it to the quarterfinals, which qualified him for the 1960 Masters. Harrison qualified for the U.S. Amateur sixteen times in his career.

His opportunity to play in the 1960 Masters led to a practice round playing with Palmer and Hogan in 1960. When they made the turn in that practice round, Hogan asked Harrison where they stood in their bet between the two of them (there was another team bet being played). "You're four down," replied Harrison, who had shot a 31 to Hogan's 35. "Then I guess I better press

Jack Key with his 1961 trophy for winning the Georgia State Amateur Championship.

EISENHOWER AT GLEN ARVEN IN 1956

It was on the eighteenth hole of Glen Arven in Thomasville in 1956 that then President Dwight D. Eisenhower deemed himself fit enough to run for another term as president of the United States. Recovering from a heart attack, Eisenhower was walking the golf course during a round of golf. The eighteenth hole at Glen Arven finishes with a long, steeply uphill slope to the green (see photo at the opening of Chapter 1). Eisenhower announced that if he could manage that climb up the eighteenth at Glen Arven, then he was fit enough to run for a second term of office as president. He made the climb successfully. He did wait until returning to Washington before making the decision public. Because of the importance of Eisenhower's health and interest in whether he would run again for President, the story made headlines in the national media.

Young Valdosta golfers in the 1950s. *From left to right*: Jack Oliver III, Wilbur Warner, Frank Eldridge, William Adams and Bunky Henry, who went on to win the 1964 State Amateur Championship.

you on the back side," Hogan replied. Harrison smiled back at him and said, "Mr. Hogan, I wish I had a recording of that."

Another dimension to Harrison's involvement with golf began when Tom Cousins called on him in 1995 to assist with creating opportunities for the youth residing in the East Lake area to have new positive experiences, as well as an introduction to golf—one element in the overall redevelopment of the neighborhood. Harrison assembled a nearly two-week series of outings for about forty neighborhood children. The program included field trips to the Falcons training camp, Chick Fil-A's offices, Equifax and other sites, as well as motivational talks by successful African American businessmen. Ultimately, a First Tee program was established at East Lake, training young people to play the game, as well as teaching them life skills.

Harrison served as president of the Atlanta Golf Association from 1971 to 1985, supervising the Atlanta Open, Atlanta Amateur and Atlanta Junior tournaments. He also served as a director of the Southern Golf Association.

The initial discussions that led to the founding of Cherokee Town and Country Club were held at the home of Pat and James "Hoss" Williams in August 1955. Craigellachie, the former 112-acre Grant estate on West Paces Ferry Road in Buckhead, was chosen to be transformed into the Town clubhouse for the new club. Louise Suggs, a friend of the Grants' daughter, spent the night at the Grant home while in high school.

Shortly thereafter, land was sought for the Country Club site, which was identified just south of the Chattahoochee River near Roswell Road, and the golf course first saw play in December 1957. Less than a year after the first eighteen holes at Cherokee opened for play, the club hosted the Carling Open, a PGA Tour event, whose field of players included Billy Casper, Dow Finsterwald and Arnold Palmer. Julius Boros, winner of the 1952 U.S. Open and still the oldest person to win a major for his victory at age forty-seven in the 1963 U.S. Open, won the 1958 Carling Open.

Jack Lumpkin became golf director at the club in 1972. His wife, Sherry, was responsible for organizing the Georgia Girls

Golf Association, which assisted in the development of Laura Player, Ruth Ann Lazenby and Cathy Tatum. Lumpkin's son Jay won the Greater Atlanta Junior Golf Association Championship in 1973. Jack Larkin of Cherokee won the U.S. National Junior Championship in 1981.

Randy Nichols became greens superintendent at Cherokee in 1975, eventually being elected in 1993 as president of the eleven-thousand-member Golf Course Superintendents of America Association (GCSAA). Nichols was named Georgia Superintendent of the Year in 1993 for his lifetime achievements, and he has also received the GCSAA's Distinguished Service Award.

Cherokee had added nine more holes to its original eighteen by 1970 to meet the needs of its growing membership. On September 7, 1985, an additional nine opened. Later, Tom Fazio directed significant renovation work on what are now called the North Course and the South Course.

Several club members have been prominent in senior golf. Richard Tatum won the GSGA State Senior Amateur in 1996, a year he was named Senior Player of the Year in the state. His daughter is Cathy Tatum. Joe Estes of Cherokee has twice won the State Senior Amateur, in 1989 and 1998. Four members in the 1990s qualified for the USGA Senior Open: Joe Estes, Amos Jones, Richard Tatum and Richard W. Van Leuvan. Eleven-time club champion Bob Young qualified multiple times for the USGA Mid-Amateur and for the U.S. Amateur.

With so many members who have enjoyed every level of competition in golf and every aspect of the lore of the game, it is no wonder that Cherokee has one of the finest golf art and memorabilia collections anywhere in the world. Wayne Aaron, who has served as chairman of the Art Evaluation and Acquisition Committee for Cherokee, assisted with the development of Cherokee's collection, as well as personally assembling one of the most significant collections of golf artifacts and memorabilia. Aaron's friend Dick McDonough, who resides at the Landings on Skidaway Island near Savannah, is also recognized as one of the foremost collectors of golf memorabilia in the nation.

Cherokee served as the host site for the 1999 USGA Women's Mid-Amateur Championship on its North Course,

with Alissa Herron winning. The club first hosted the GSGA State Amateur Championship in 1973, won by John Bodin; then in 2001, won by Michael Webb; and again in 2011, won by David Noll Jr.

In 1958, Bobby Jones was given an opportunity to revisit St. Andrews, Scotland, as the non-playing captain of the United States team in the first tournament for the Eisenhower Trophy, a world amateur team event. When it was learned that Jones would be returning to the city where he won the British Amateur in 1930, part of his Grand Slam that year and his first return to the city since 1936, the city decided to confer on him the Freedom of the City and Royal Burgh of St. Andrews. This had been presented to an American only once before: to Benjamin Franklin in October 1759. The special relationship between Jones and St. Andrews is revealed in the remarks by Mr. Robert Leonard, the provost of St. Andrews, who stated, "We wish to honor Mr. Jones because we feel drawn to him by ties of affection and personal regard of a particularly cordial nature, and because we know that he himself has declared his own enduring affection for this place and for its people."

In the ceremony presenting him with the Freedom of the City, Jones stated that "if I could take out of my life everything but my experiences in St. Andrews, I would still have had a rich, full life." Upon his return to Atlanta after the ceremony, he said that the honor bestowed on him was "the finest thing that ever happened to me."

Billy and Jack Key made their mark on Georgia golf in the postwar era.

Charlie Harrison.

Jack was born in Columbus, Georgia, on November 11, 1927. Captain of the Auburn University golf team for four years during the 1950s, he later won the Georgia Amateur twice, the Southeastern Amateur twice and the Gala Seniors Championship three times. In 1971, he co-founded the Fred Haskins Award, honoring each year's best college golfer. He has been a member of the GSGA board of directors and both a board member and golf chairman at Green Island Country Club and the Country Club of Columbus, where he served as president in 1965–66. Key was also a co-founder and board member of Bull Creek Municipal Golf Course in Columbus.

James W. "Billy" Key was born in Columbus, Georgia, in 1931. After some victories as a collegiate golfer, Billy won the 1958 Western Amateur, the 1962 Southeastern Amateur and the 1968 Georgia State Amateur. As a senior, he won the American Seniors Best Ball Championship five times. A member of the U.S. Seniors International Team, Billy was team captain in 1994 and 1995. In 1990, he was ranked "#2 Senior Golfer in the United States" by *Golf Digest*. He has been a director of the Southern Golf Association and served as president from 1978 to 1979.

As the 1950s drew to a close, Georgia was primed for golf to enter a phase of development that was unprecedented. Fueled by population growth, especially in the Atlanta metropolitan area, golf courses were built to accommodate increased demand. As the prestige of The Masters grew, it influenced golfers across the state to emulate the remarkable players who were making history every spring in Augusta.

The Landings.

TOURNAMENTS AND TITLES

1961–1984

While the 1960s are recalled as years of turmoil in America in the political realm, in Georgia golf flourished and continued to grow. New courses were built, PGA tournament golf came to Atlanta on a permanent basis and the state continued to produce golfers who excelled not only at the local level but nationally as well. Among them was Doug Sanders, originally from Cedartown, Georgia. In his career, he amassed twenty-one victories on the PGA and Champions Tours. Sanders captured five PGA Tour wins in 1961, playing on the Ryder Cup team in 1967. Because he placed second at the 1959 PGA Championship, the 1961 U.S. Open and the 1966 and 1970 British Opens, he was known as a perennial runner-up.

At The Masters, two players dominated the decade of the 1960s. Arnold Palmer's heroics added three more green jackets to the one he collected in 1958, winning in 1960, 1962 and 1964, while Jack Nicklaus won in 1963, 1965 and 1966. Nicklaus would go on to win three more Masters, in 1972, 1975 and, in a crowning achievement at age forty-six, the 1986 tournament.

Gunby Jordan, born in Columbus, Georgia, on November 2, 1915, brought the PGA Tour to an area of Georgia it had never visited before. In 1961, he created the Green Island Hills residential community and Green Island Country Club, designed by George Cobb, which later hosted more than twenty years of PGA tournaments. He organized the first PGA tournament to be held in Columbus, the 1970 Southern Open, and traveled the PGA Tour regularly to attract the top names in golf to participate. When it was announced that the city of Columbus would close its only par 3 golf course, Jordan personally leased the course and maintained it for the use of young golfers in what he called his "Seniors for Kids" program. This program utilizes the skills and knowledge of senior golfers while developing the skills and enriching the lives of Columbus's golfing youth.

Janet Dobbins Olp, born in Savannah, Georgia, began winning championships at the state level in 1961, capturing her first of two Georgia Junior Girls Championships. She eventually won six Atlanta Women's Golf Association Championships and the GWGA Championship six times. In 1985, she won the AWGA, the GALGA and the GWGA Championships and the GWGA Four-Ball Tournament in the same year. She has been the Atlanta Country Club's Women's Champion ten times.

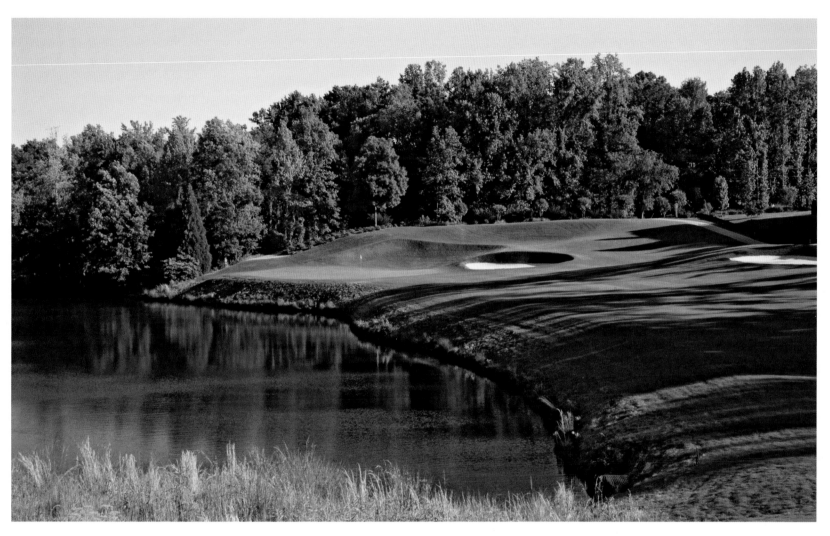

Pinetree Country Club.

Opposite: Green Island Country Club.

In 1962, Dan Nyimicz accepted the position of head golf professional at Idle Hour Club in Macon. While there, Nyimicz developed a junior program that produced several outstanding individuals. These include fellow Georgia Golf Hall of Famer Peter Persons, a finalist in the U.S. Amateur, and Jimmy Hodges, a teaching professional at Sea Island

Golf Club and a member of the *Golf Digest* teaching team. A founding member of the Georgia Junior Golf Foundation, Nyimicz served as its treasurer, secretary and president. He was also deeply involved in the Georgia PGA, rising to the office of president.

Pinetree Country Club, designed by Chick Adams, opened originally in 1962 as the O.B. Keeler Golf Course, named for the chronicler of Bobby Jones's career. As a testament to the course's true championship character, the

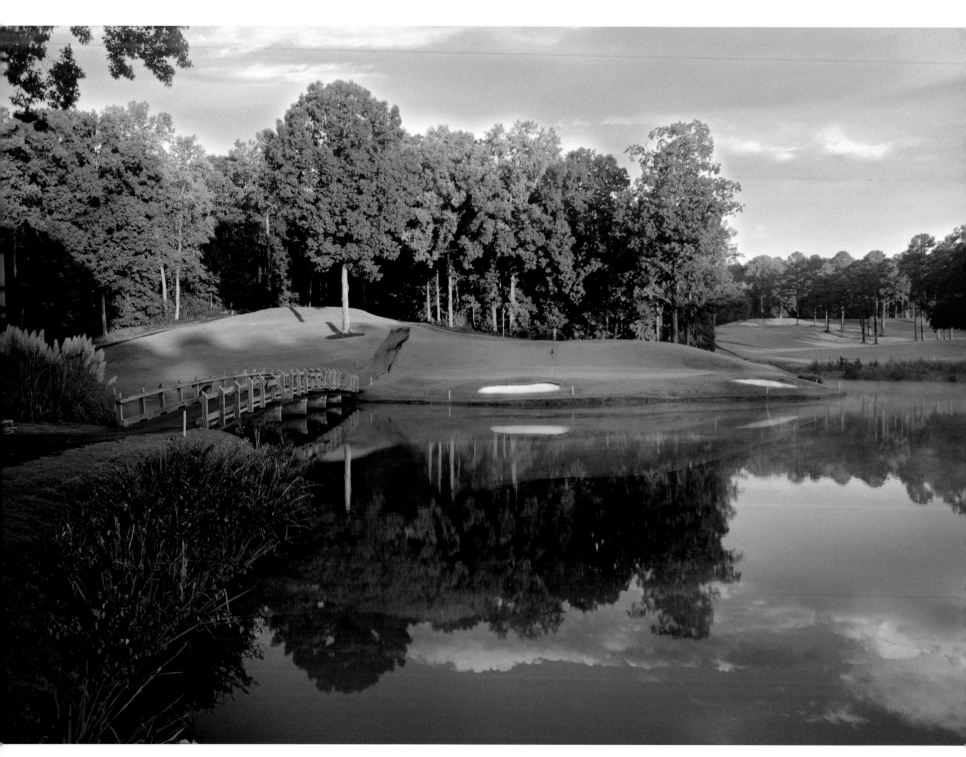

University of Georgia Golf Course.

club hosted the Georgia State Amateur Championship in 1976, 1985, 2003 and 2013. Additionally, the club held the 2014 and 2015 Georgia Opens of the Georgia PGA and has been the site for qualifying for numerous Georgia and U.S. Amateur Championships. Larry Nelson, who did not take up golf until his early twenties, had his first job in golf as an assistant professional at Pinetree Country Club. Nelson went on to a Hall of Fame career, winning the U.S. Open and twice winning the PGA Championship. The golf course was renovated in 2007 and 2008 under the direction of architect Bill Bergin. The course now plays to 7,108 yards at a par of 72.

Jimmy Gabrielsen, who achieved All-American status at the University of Georgia in 1963, went on to play on the 1971 Walker Cup team and served as team captain in 1981 and 1991. Gabrielsen led Georgia to three consecutive Southeastern Conference championships. A former runner-up in the British Amateur Championship, he went on to play The Masters for the first of three times that April (1963, 1971 and 1972). "It was totally unlike any other experience," said Gabrielsen, describing playing at Augusta National in The Masters. "It's very hard for an amateur playing in front of that many people. It's pretty serious stuff down there when they tee it up on Thursday. It never really got any easier."

In 1964, Ceil MacLaurin, born in Fitzgerald, Georgia, won the GWGA Match Play Championship at Athens Country Club. She repeated as champion in the event the following year and in 1970, eventually winning the event a total of eight times. At that time, the GWGA held a medal play championship, which MacLaurin won in 1965, 1968 and 1969. The GWGA initiated its stroke play championship in 1971; MacLaurin won four of these in a row, starting in 1972. She also competed successfully at the national level, with seventy-five tournament titles to her credit, including the 1976 U.S. Senior Women's Championship, seven North-South Seniors Championships, the Women's Senior Southern Golf Association Championship and the Canadian Senior Championship.

Ceil MacLaurin.

Billie Wickliffe from Athens won several GWGA titles, starting with the 1964 Medal Play Tournament and then capturing it again in 1966 and 1967, followed by the 1970 Medal Play Tournament and the 1971 Stroke Play Championship. She served as GWGA president in 1971. A life-long member of Athens Country Club, she has won the Ladies Club Championship there numerous times. The club

holds an annual invitational golf tournament in her honor each June.

The state Amateur Championship in 1965 featured a repeat winner who accomplished the feat with the most years between victories: twenty-eight since his first win in 1937. Frank X. Mulherin Jr. was born in Augusta on March 20, 1915. He was nicknamed by fellow golfers as "the Mule." The win in 1965 at age fifty set the record for the oldest winner of the State Amateur. He was also a runner-up in the State Amateur three times. In addition to an impressive amateur record, Mulherin was active in the local and state golf communities. Mulherin supported the golf program at Augusta State University and was a founding member of the Augusta Golf Association, an organization committed to promoting junior golf.

The Rocquemore family, whose first contributor to golf was Bill Roquemore, a pioneer in commercializing forage and turf grasses in Georgia, eventually established a series of golf clubs in Atlanta that brought affordable quality golf to thousands of golfers. Canongate 1 near Palmetto, Georgia, opened for play in September 1965. In 1995, the National Golf Foundation presented the Jack Nicklaus Golf Family of the Year Award to the Roquemore family for their contributions to the game of golf. Mr. Roquemore died in July 1997.

In the 1950s, Roquemore influenced the planting of coastal Bermuda grass in Texas, Oklahoma, Arkansas and Louisiana, generating interest in the product. Today, Coastal Bermuda is planted on about ten million acres in the United States.

After growing up around the turf business started by his father, William A. "Rocky" Rocquemore, Bill's son, joined golf course architect Joe Lee in the course design business at age twenty-two in 1970. Lee, who himself early in his career benefited from the tutelage of designer Dick Wilson, was one of the most prolific designers in America from the 1950s through the 1980s.

Among the 174 Rocquemore-designed courses are Magnolia Palm and Buena Vista at Disney World, La Costa in San Diego and Cog Hill in Chicago. He has had courses named "Best New Course" by *Golf Digest* three times and once by *Golf* magazine.

LAYNE WILLIAMS

Layne Williams, while caddying for another golfer in Gary Player's group, witnessed Player in the late 1960s tie the course record of 63 at Sunset Country Club in Moultrie during a charity exhibition round. The other players were Fred McDuffie, Bunk Berry and former GSGA State Amateur champion Dynamite Goodloe.

Gary Player with Layne Williams.

Rocky Rocquemore's sister, Mrs. Lee Burton, served as vice-president of Golf Operations for Patten Seed Company and formerly managed the golf clubs in the Canongate system. She is a past president and chairwoman of the board of the Georgia Women's Golf Association, member of the Georgia State Golf Association Board of Directors and chair of the Women's Tournament Committee. Aside from golf management and service, Burton is an excellent player. She was named Georgia Female Player of the Year in 1994 and 1996, and she is a three-time Greater Atlanta Champion. She has played in six USGA Mid-Amateur Championships and one USGA Amateur Championship.

The city of Atlanta hosted several professional tournaments going back to the 1930s. In 1967, Atlanta Country Club served as the host site for the first Atlanta Classic, a stop on

the PGA Tour that would have a title identified with several corporate sponsors. The event attracted the best golfers in the game, and the list of winners reflects that: Bob Charles (a British Open champion); Georgia's own Tommy Aaron (a Masters winner); Jack Nicklaus (fourteen majors, including six Masters); Hale Irwin (three U.S. Opens); another Georgian, Larry Nelson (three majors); Tom Watson (seven majors); Tom Kite (U.S. Open); Cory Pavin (U.S. Open); Tiger Woods (fourteen majors); and Phil Mickelson (five majors). The last two golfers won when the event was hosted at Sugarloaf. The event was not played in 1974, when the Tournament Players Championship came to Atlanta, nor in 1976, when Atlanta Athletic Club hosted the U.S. Open. The tournament moved to Sugarloaf, north of Atlanta, for its final eleven years. The Atlanta Classic event ceased after 2007, mainly because the Tour Championship had come to Atlanta on what was conceived of as a permanent basis.

Now designated the Tour Championship by Coca-Cola, the event comprises the top-thirty money leaders of each year's PGA Tour season. Since 2007, it has been the final event of the four-tournament FedEx Cup playoff, and eligibility is determined by FedEx Cup points amassed throughout the season. The Tour Championship in Atlanta is now the final event of the PGA Tour season.

The USGA Senior Amateur Championship was played at Atlanta Country Club in September 1968. Bobby Jones accepted an invitation to speak at the players' dinner on the evening before play started. His remarks included the following passage:

> There seems to be little appreciation today that golf is an amateur game, developed and supported by those who love to play it. Amateurs have built the great golf courses where the playing professionals play for so much money; amateurs maintain the clubs and public links organizations that provide jobs for the working professionals; amateurs spend millions of dollars each year on golf equipment and clothing; and amateurs rule and administer the game on both sides of the Atlantic. In this way, golf has prospered for centuries. It would appear to be the best possible arrangement.

Designed by Robert Trent Jones Sr., the University of Georgia's golf course opened in 1968. The course has hosted many NCAA Championships and other tournaments, including the Liz Murphy women's collegiate tournament, the oldest women's college event in the nation, named for the former UGA women's team coach. The university has been fortunate in the quality of its coaches for both men's and women's teams. A list of former members of the school's golf teams reads like a who's who in golf for the past one hundred years. Even before the golf course opened, the men's team won the SEC team championship five years in a row, from 1961 to 1965. The University of Georgia men's team won the NCAA team championship in 1999 and 2005.

Hobart Manley Jr., born in Savannah in 1926, was one of the early participants on successful UGA golf teams. After college, starting in 1948, he played in six U.S. Amateurs, three British Amateurs, two French Amateurs and one Canadian Amateur. Manley's tournament titles include the 1951 North-South Amateur and the 1954 Southeastern PGA Open. He teamed with Marlene Streit to win the 1953 and '63 National Mixed Foursomes tournaments.

Collegiate golf has always been strong in Georgia. Bobby Jones played for the Georgia Tech team, as did Watts Gunn and Charlie Yates and his brother, Dan (Dan's son Danny played for UGA). Tech has had a remarkable string of players go on to the ranks of the professionals. Some notable Georgia Tech golfers who have played on the PGA Tour are David Duval, Stewart Cink, Troy Matteson, Larry Mize, Bryce Molder, Cameron Tringale and Matt Kuchar.

A.J. "Duck" Swann was the Southeastern Conference champion in 1948 at Georgia Tech and was captain of the Yellow Jackets' 1949 SEC title team. Swann earlier played on the Lanier High golf team and won the 1941 Macon

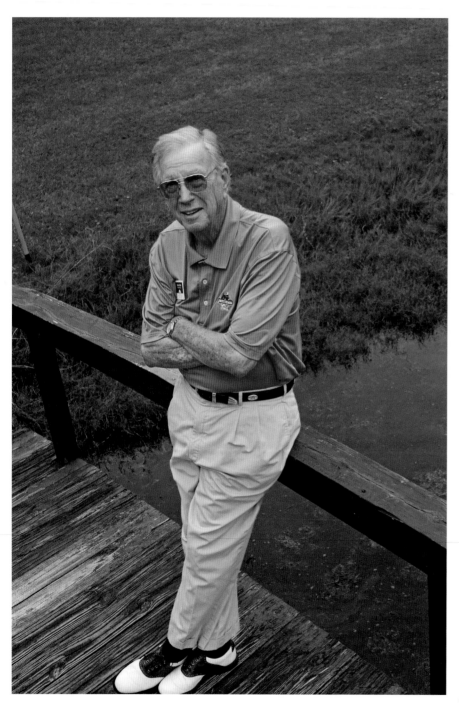

Johnny Paulk.

City and 1942 Georgia Interscholastic titles. Swann turned senior amateur at the age of fifty-five in 1980 and began competing at the highest levels of the game. His most significant victory came in 1983 at Walton Heath in England when he became the first American to capture the British Senior Open Amateur. Also during that year, he won the Georgia Seniors title and qualified for the match play portion of the USGA Senior Amateur Championship.

Augusta State, part of the University of Georgia system, won the NCAA Division I Men's Collegiate Golf Championship in 2010 and 2011. The school, which competes in Division II in all sports except golf, became the first team to win back-to-back titles since Houston did it in 1984 and 1985. Patrick Reed, now a multiple winner on the PGA Tour, played for the Augusta State championship team.

Johnny Paulk is a native of Georgia, born in Valdosta. He has been affiliated in several roles with Jekyll Island Golf Club since 1968. Among some of his honors are the Governor's Faithful Service Award and the President's Award from the Georgia PGA, and he is the recipient of Spalding's Professional of the Year.

His may be a familiar face to attendees of The Masters Tournament, where Johnny has served as a tee announcer since 1979. He has sometimes tried to keep golf fans informed about how the players are doing on the course. One year, after he asked, "Does anybody need a score?" a voice in the crowd responded, "What was the score of last year's Georgia–Florida game?"—a game that Georgia lost. Paulk declined to provide those numbers.

Thousands of golfers have participated in the annual Georgia–Florida Golf Classic, an event hosted by Paulk, which has been held every fall at Jekyll Island for over thirty years. Four-person teams are paired during tournament play and flighted after the first day.

Hollis Stacy, born in Savannah, is another in the line of Georgia golf prodigies. In 1969, at the age of fifteen, she was the youngest player ever to win the U.S. Junior Girls Championship and then repeated in 1970 and 1971. She won the 1970 North-South Amateur and was a member of the 1972 Curtis Cup Team. Joining the LPGA Tour in 1974, her seventeen victories include three U.S. Women's Opens. She continued playing professional golf into the early 2000s, scoring a win on the Women's Senior Golf Tour in 2001.

Indian Hills Country Club opened in 1969, part of a large subdivision of 1,350 homes that made it, at the time, the largest single-family subdivision between Washington, D.C., and Houston, Texas. Joe Lee designed the club's twenty-seven holes. From 1972 through 1975, the club hosted the LPGA-sponsored Lady Tara event.

Darwin White, former director of golf at Indian Hills, recalled watching future PGA Tour professional Bob Tway, who went on to win the PGA Championship in 1986, as a teenager spending three hours on the practice tee at the club, playing eighteen holes and then spending another two hours on the putting green. In 1986, Tway was named PGA Player of the Year—recognition for winning four PGA Tour events and finishing second on the money list.

The winner of the 1970 U.S. Women's Amateur, Martha Wilkinson Kirouac, later moved to Georgia in the 1970s and both competed well and served the game of golf. She played on the 1970 and 1972 Curtis Cup teams, serving as the captain of the victorious 2004 team, and participated on the 1970 Women's World Amateur Team. After she moved to Georgia, she won two Atlanta Women's Golf Association championships and the 1986

Hollis Stacy.

Peter Persons.

Georgia Women's Golf Association championship, finishing as runner-up the following year.

In service to the game, Kirouac was the first female elected as a director of the GSGA and then became a member of the executive committee and vice-president of the organization. She became an employee of the GSGA in the 1990s, becoming director of course rating and member services. Then, in 2013 and 2014, she served the organization as executive director.

Just one month before he died in 1971, Bobby Jones wrote a letter to the USGA with an invitation from the club to host a U.S. Open, which Jones described as his favorite event. Though he did not live to see the 1976 U.S. Open conducted on the Highlands course at the Atlanta Athletic Club, Jones's invitation certainly was a key influence on the event coming to the club. If the U.S. Open was Bobby Jones's favorite event, he was the favorite champion of the USGA.

As tribute to Mr. Jones's place in the game of golf, the highest honor bestowed by the USGA is the annual Bob Jones Award. Atlanta's own Tom Cousins and Charlie Yates have been given the Bob Jones Award. The award is not for excellence in competitive golf; rather, it is how Jones conducted himself as a player as much as the scores he posted that distinguished him.

More than three decades later, Jones described in the book *Golf Is My Game* his appreciation for the rules of the game and etiquette: "It is of the very essence of golf that it should be played in a completely sociable atmosphere conducive to the utmost in courtesy and consideration of one player for the others, and upon the very highest level in matters of sportsmanship, observance of the rules, and fair play."

The winner of the 1972 State Amateur Championship, Lyn Lott, was born in 1950 in Douglas. While at Coffee County High School, Lott twice won the Georgia state high school championship, the Georgia State Junior and the Southeastern Junior Amateur. He also won the Georgia State Jaycees Championship and the Future Masters. At age seventeen, Lott became the youngest person to win the Georgia Open. Lott competed on the PGA Tour for eleven years, participating in three Masters.

The Atlanta Junior Golf Association (AJG) traces its origins to 1974 (initially the DeKalb Junior Golf Association). During its inaugural season, ninety-nine boys and girls registered to play a schedule of a half dozen events. The cost was two dollars. The season-ending Grand Championship, held at Pinehurst #2, closed out a successful first season and laid the foundation for the successes AJG has realized since.

The organization grew rapidly, with membership peaking at more than 1,600 junior golfers in 2000. Nearly 10,000 junior golfers have been introduced to the game by the AJG. The association offers nearly one hundred tournaments a year that include multi-day competitions, team match play, Ryder Cup–style events, individual match play, four-ball stroke play, events designed with beginning golfers in mind and the staple single-day Summer Series events.

AJG recognized the need to increase its involvement in the community, so the Atlanta Junior Golf Foundation (AJGF) was incorporated in 1988, also as a 501(c)(3) entity. This foundation was developed to assist those players with financial need gain access to equipment, instruction and AJG programs. Additionally, the resources of the foundation are used to make capital improvements and updates to the association as needed.

The Landings community on Skidaway Island, twelve miles from Savannah, opened in 1974. The Landings Club there is a private golf club that offers members access to six championship

golf courses and other amenities. Some of the most accomplished golf course architects have done work on the Landings courses. In 1974, the Marshwood course opened, attributed to Arnold Palmer. Then, Palmer and Ed Seay designed the Magnolia course, which opened in 1979. That was followed by the Plantation course, designed by Willard Byrd. The Palmetto course opened in 1985, done by Arthur Hills, who also designed the Oakridge course, opened in 1988. In 1991, the Landings added the Deer Creek course, designed by Tom Fazio. The Landings Women's Golf Association is the largest, club-based, amateur women's golf organization in the United States.

The 1976 U.S. Open hosted by the Atlanta Athletic Club was the first to be played in the Deep South. Champions Golf Club in Houston and Colonial in Fort Worth, Texas, had hosted the event, but no state east of Texas and south of Kentucky had previously hosted.

A very special shot concluded that Open. Leading by one stoke after his first shot on the eighteeth hole in the fourth round, Jerry Pate had a 190-yard

Jerry Pate celebrating his 1976 U.S. Open win at Atlanta Athletic Club.

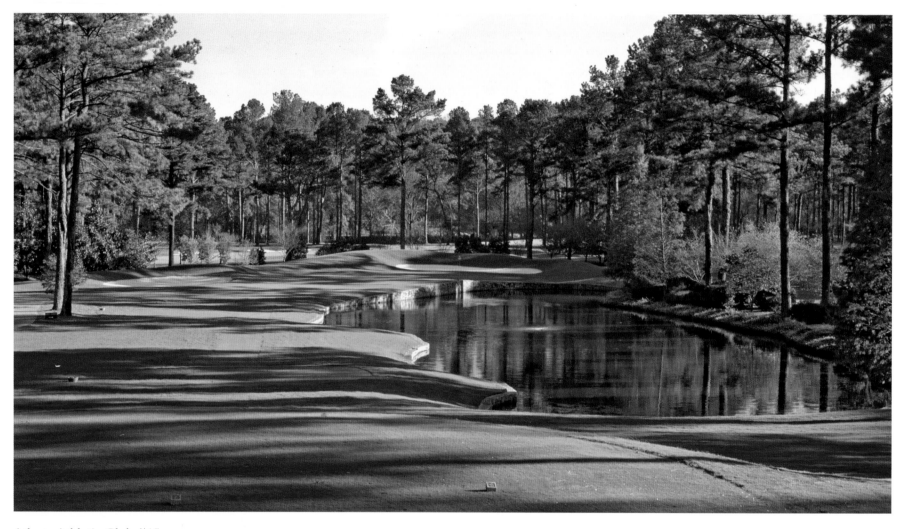

Atlanta Athletic Club #15.

shot over a pond in front of the green to try to ensure his par. His ball was in the rough but in a fairly good lie. "I've got to go for it," Pate told his caddie. "This is my one big chance to win the Open." Pate was twenty-two years old at the time.

The shot he hit not only found the green but also ended up in nearly tap-in range—a putt he made. He ended

the championship two shots ahead of Tom Weiskopf and Al Geiberger. The spot where Pate struck the remarkable approach is now commemorated with a plaque.

Founded in 1978, the American Junior Golf Association has its headquarters on the grounds of Chateau Elan in Braselton. With a full-time staff of more than sixty people, it is a 501(c)(3) nonprofit organization "dedicated to the overall growth and development of young men and women who aspire to earn college golf scholarships through

competitive junior golf," as its mission states. More than six thousand young people compete in its more than one hundred tournaments and qualifiers annually. A measure of the AJGA's success is that more than three hundred AJGA alumni play on the PGA and LPGA Tours and have earned more than six hundred Tour victories.

AJGA alumni on the PGA Tour include: Rickie Fowler, Charles Howell III, Phil Mickelson and Jordan Spieth. AJGA alumnae on the LPGA Tour include: Paula Creamer, Stacy Lewis, Inbee Park and Morgan Pressel. At the college level, twenty-four of the past thirty-two NCAA Division I men's champions and twenty of the past twenty-six NCAA Division I women's champions are AJGA alumni.

A Georgian won the 1983 U.S. Open. With the 1981 PGA Championship win already on his resume, at the Open in 1983 Larry Nelson ended the second round in twenty-fifth place, seven shots behind the leader. He was far enough from the lead that, under the difficult course setup at Oakmont Country Club that year, it seemed like an impossible position from which to advance into contention. His 67 in the third round would be the lowest round of the championship, followed by a 67 on Monday in the rain-delayed event, allowing him a one-stroke win over Tom Watson. Nelson's 67/67 over the last thirty-six holes broke a fifty-one-year Open record established by Gene Sarazen. Nelson added another PGA Championship win in 1987 by winning a playoff over Lanny Wadkins. Nelson participated on the U.S. Ryder Cup team in 1979, 1981 and 1987.

Steve Melnyk, born in Brunswick, Georgia, in 1947, won the 1969 U.S. Amateur at Oakmont Country Club. The event had changed from a match-play format to stroke play in 1965. Melnyk's score of 286 was just three stokes higher than the score attained by Jack Nicklaus and Arnold Palmer at Oakmont in regulation play for the 1962 U.S. Open, when they equalled the score Ben Hogan had achieved in winning the 1953 U.S. Open at Oakmont.

Melnyk won the 1965 Georgia Open at age eighteen. A graduate of the University of Florida in 1969, he won nine collegiate events and All-American honors. Adding to the U.S. Amateur win, Melnyk captured the British Amateur and the Eastern Amateur and was a member of the 1969 and '71 Walker Cup teams. Melnyk competed on the PGA Tour starting in 1972 and competed for ten years until a 1982 elbow injury prevented further professional competition.

Davis Love Jr. served as head professional at Atlanta Country Club from 1965 to 1977. He played in eight U.S. Opens, three PGA Championships and two British Opens. He also played in two Masters Tournaments—as an amateur in 1955 and as a professional in 1965. He won two Georgia PGA Championships. He joined the *Golf Digest* Schools in 1975, writing thirty-five major articles on instruction over the next thirteen years.

His son, Davis Love III, extended his prominence as a player on the PGA Tour for more than twenty years into a lucrative and promising career as a golf course architect. Davis and his brother, Mark, operate Love Designs, noted for its work at Kinderlou Forest Golf Club in Valdosta and Windermere in Atlanta. The firm did a renovation of the Retreat course at Sea Island, and other notable designs include the Patriot Golf Club at Grand Harbor in Ninety Six, South Carolina, and the Love course at Barefoot Resort in Myrtle Beach. During his career on the PGA Tour, Davis was a member of five President's Cup teams, five Ryder Cup teams and five World Cup teams. Davis earned his first major at the 1997 PGA Championship. His victory at age fifty-one in the 2015 Wyndham Championship, his third time to win the tournament, made him the third-oldest winner in PGA Tour history, trailing only Art Wall Jr. and Sam Snead. Love served as captain of the 2012 U.S. Ryder Cup team, a role that he will repeat in 2016.

By 1980, there were over 5,908 USGA-affiliated clubs. That figure grew to over 10,600 by 2013. As noted by Steve Mona in his role as the CEO of the World Golf Foundation, while there has been some contraction in the number of golf courses since the beginning of the 2007–08 economic recession, the number of golf courses is still more than 80 percent higher than in 1980.

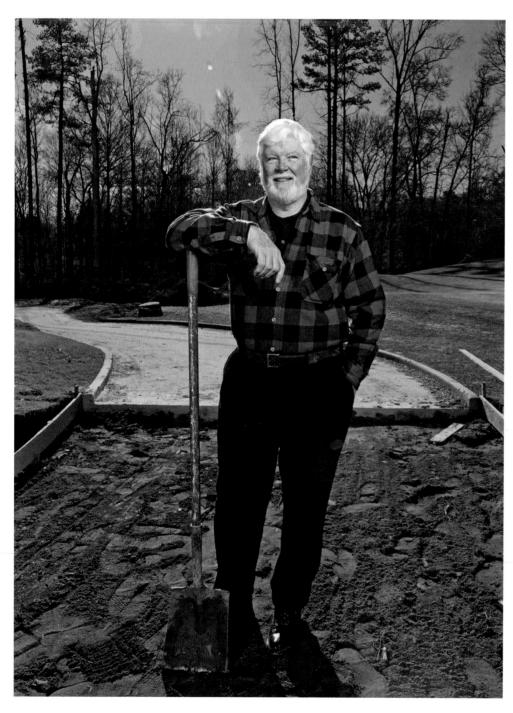

Bob Cupp.

Georgia has been fortunate in having several resident golf course architects whose designs are world renowned. Bob Cupp, who resides in Atlanta, started with Nicklaus Design in 1973 and later went out on his own. The USGA used Cupp's solo-designed Witch Hollow course at Oregon's Pumpkin Ridge for both the 1997 and 2003 U.S. Women's Opens and Ansley Golf Club's Settindown Creek Course in Roswell, outside Atlanta, for the 2005 Women's Amateur. The Plantation Course at Reynolds Plantation, as well as Marietta Country Club, are also by Cupp.

Another Georgian, Denis Griffiths, started his design career in 1970, opening his own firm in 1986, and counts fourteen courses in Georgia alone to his credit. His two most recent projects are Crystal Lake Golf and Country Club in Hampton and Crystal Falls Lake and Golf Community in Dawsonville.

Mike Young has been very active around the state, with sixteen courses attributed to him, the most notable being Cateechee Golf Club near Lake Hartwell in northeast Georgia. Michael Riley has three solo projects in the Atlanta area: Crooked Creek Golf Club in Alpharetta, Reunion Golf Club in Hoschton and Governors Towne Club in Acworth. He has been acclaimed for recent renovation work on the Standard Club and Rivermont Golf & Country Club.

Bill Bergin is another of the younger generation of architects; he launched his own design company in 1994. The Auburn

Course Rating: The Basics

Course rating is an important core service that the Georgia State Golf Association provides to its member clubs. The GSGA maintains accurate and up-to-date measurements and USGA course rating/slope rating information for golf courses in Georgia. Courses are rated at least every ten years or when substantial changes are made to them to ensure that golfers are playing on courses with accurate course and slope ratings. GSGA course rating volunteers are trained annually to guarantee that their work is done in accordance with the current standards of the USGA course and slope rating system.

Rating a course involves many considerations. When rating a hole, the rater evaluates the hole's effective playing length, which considers roll or elevation changes; extreme rough; landing zone; line of play, which is affected if a lake or other water hazard borders a fairway or a continuous string of bunkers; obstacle squeeze; and tier on a green, among other things. Then, within the considerations mentioned, there are gradations or degrees of difficulty, especially for the average or high-handicap golfer. Suffice it to say, course rating is complicated, but raters perform a very thorough and precise protocol when rating any golf course.

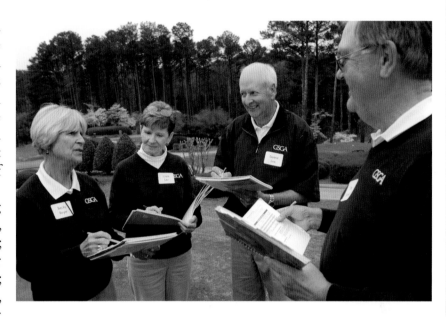

Course raters from the GSGA: Becky Royer, Linda Lee, Dennis Lee and Tom Dvorak.

University Club is his design, as are the Golf Course at Caesars in Indiana and the Club at Fairview Plantation outside Nashville.

The past thirty years have been a particularly busy time in course development in Georgia because of the state's growth. As the population nearly doubled, the number of golfers increased. Golf course home communities have been especially in demand. Not only the Georgia-based designers mentioned but also Tom Fazio, Jack Nicklaus and Rees Jones have done work in Georgia. Rees Jones has been very active in the state. Among his original designs and renovations are Atlanta Athletic

Club (Highlands Course), Johns Creek; Atlanta Athletic Club (Riverside Course), Johns Creek; Charlie Yates Golf Club, Atlanta; East Lake Golf Club, Atlanta; Echelon Golf Club, Alpharetta; Jones Creek Golf Course, Evans; Ocean Forest Golf Club, Sea Island; Piedmont Driving Club, Atlanta; Reynolds Plantation (Oconee Course), Greensboro; Sea Island Golf Club (Plantation Course), St. Simons Island; and Southbridge Golf Course, Savannah.

The 1970s were especially productive years for the GSGA, which added services and became an integral supporter and sustainer of the game of golf. The first statewide handicap

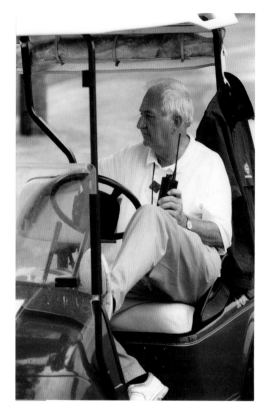

Billy Peters.

computation service was administered by the GSGA and offered to member clubs through Minimax of Dallas, Texas. By 1983, the GSGA had begun testing the GHIN handicap computation system and began a four-year plan to re-rate all member club courses in accordance with the USGA's new course and slope rating system. The first three courses to be rated under the new system were Atlanta Athletic Club, Ansley Golf Club and Perry Country Club.

The first Georgia Four-Ball Championship took place in 1972 at Spring Hill Country Club in Tifton with forty two-man teams participating. A year later, the GSGA purchased its first course-measuring instruments and began planning to rate courses for its member clubs. Indicative of the GSGA's increased activities, Floyd Doss of Fort Valley was hired in 1973 as the GSGA's first executive director and full-time staff member. His first office was located in his home in Perry. Doss would hold the position until 1979.

Billy Peters, born on July 17, 1929, began his involvement as a volunteer with the Georgia State Golf Association in 1973, serving on many committees. He has served on the GSGA Executive Committee and as chairman of the Rules Committee and has helped rate courses. From 1980 to 1982, Peters served as the GSGA president. Peters has been recognized as a rules expert and has been invited by the USGA to serve as a rules official at the U.S. Open and U.S. Amateur. While serving as the 1983 president of the Georgia Junior Golf Foundation, Peters founded the Junior Golf Academy. Peters is an honorary vice-president of the Georgia PGA and in 1996 was elected as a lifetime honorary member of the Georgia PGA.

The Junior Sectional Program of the GSGA began in 1974, with more than two thousand participants during its first summer of operation. This program continues today as an entry-level competitive experience for young golfers, and it has spawned many other local competitive organizations and events around the state. Another supporter of junior golf, the Georgia Junior Golf Foundation, was chartered in 1975. As noted by the Georgia Section PGA's website, "The GJGF was originally a joint effort between the GSGA and the Georgia Section PGA and today is operated by the Georgia PGA as the Georgia PGA Foundation. It promotes the Georgia golf license tag program, with the funds generated supporting rules and etiquette presentations and other game growth initiatives." This organization today manages the Junior Golf at Schools program, among other junior developmental activities.

The Georgia State Golf Foundation was established in 1986 as the GSGA's charitable affiliate and began granting scholarships to turf grass students. This is now called the Moncrief Turfgrass Scholarship program, named after longtime USGA Green Section agronomist James B. "Monty" Moncrief. Two early beneficiaries of this program are scholars Chuck

Steve Mona, executive director of the GSGA from 1983 to 1993.

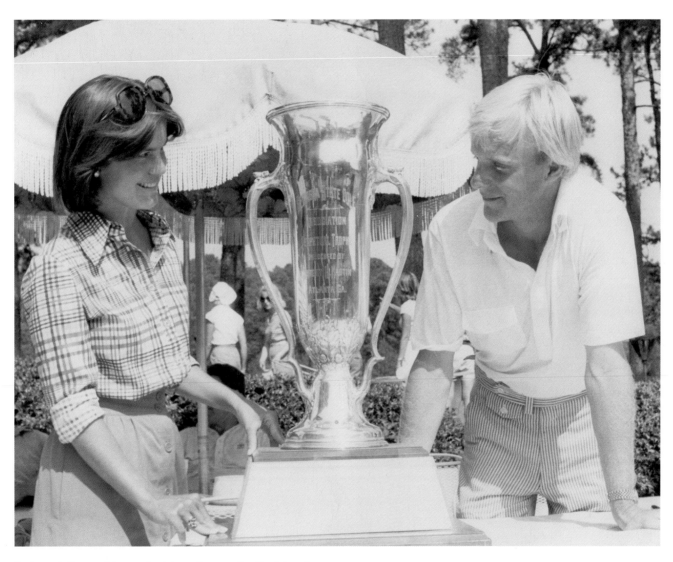

Lois and Danny Yates admiring the trophy for his win in the 1977 State Amateur Championship.

Palmer, who eventually entered a career in law, serving as president of the GSGA in 2013 and 2014, and Mark Esoda. Among many honors, Esoda has been honored nationally by the Golf Course Superintendents Association of America with its 2009 Distinguished Service Award and 2004 Excellence in Government Relations Award. In the state he has been given the Distinguished Service and Superintendent of Year awards of the Georgia GCSA and the DSA of the Georgia Section PGA. During his more than twenty-year tenure at Atlanta Country Club, it has hosted seven PGA Tour events, and he has overseen the rebuilding efforts of all green complexes, bunkers and irrigation system.

In 1979, the GSGA began to administer USGA-qualifying events in Georgia, conducting five qualifiers in that first year.

Above: Larry Nelson and his wife after he won the 1981 PGA Championship.

Left, top: GSGA volunteer Pete Crosby assisting tournament competitors.

Left, bottom: John Imlay and Charlie Yates during the 1981 PGA Championship, two men who were among the strongest supporters of golf in Georgia.

The first Girls' Championship was held in 1980 concurrently with the Junior Championship at Houston Lake Country Club in Perry.

The GSGA and the Florida State Women's Golf Association in 1981 formed the Georgia-Florida Women's Team Matches, an annual match featuring the top female players from each state. Georgia hosted the inaugural event at the University of Georgia Golf Course in Athens. The first GSGA Mid-Amateur Championship took place in 1982 at Coosa Country Club in Rome, with Ross Johnson of the host club as the first champion.

In 1983, Robert Harlin of Atlanta became the GSGA's first general counsel. Through his efforts, the GSGA was approved for nonprofit status. Harlin would later serve as the association's president from 1993 to 1994.

The naming of a Player of the Year Award was approved in 1984, in accordance with a point system that was developed. Allen Doyle of LaGrange was the first winner, and he would earn a total of seven during his career.

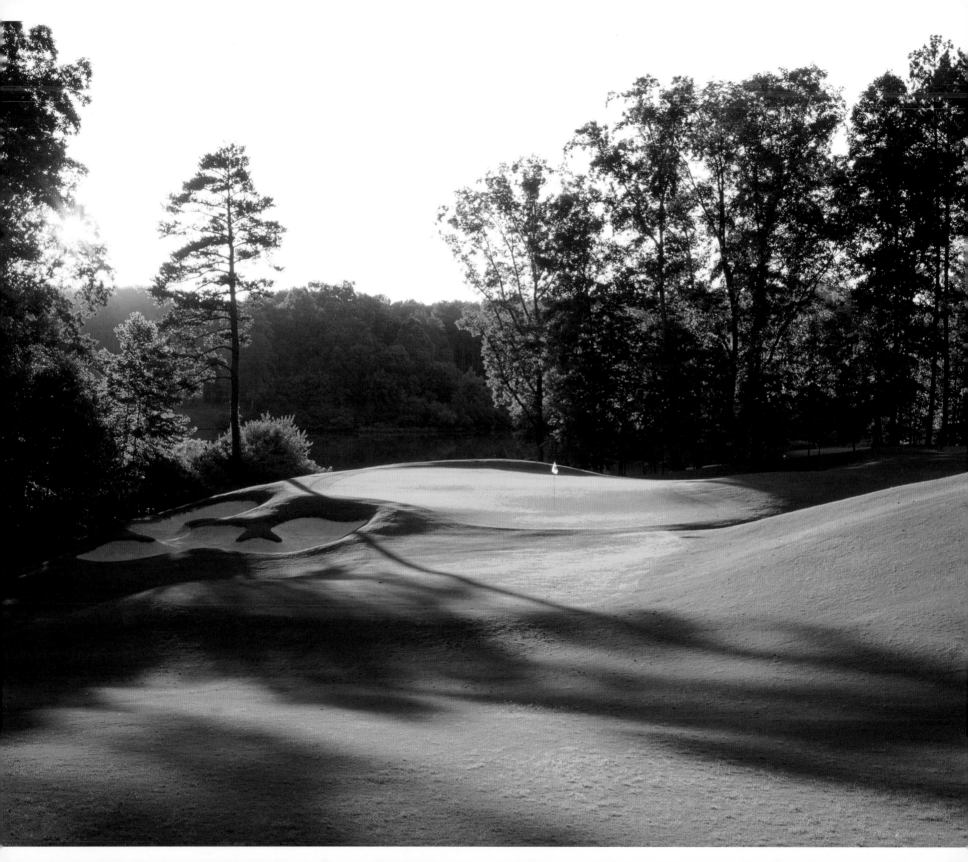

Chapter 6

CHAMPIONS AND CHAMPIONSHIPS

1984–2004

The 1980s were a busy time for golf course architecture and course openings in Georgia. New resources opened all over the state, including Whitepath Golf Course in Ellijay, designed by Joe Lee; the Club at Jones Creek in Evans, Rees Jones; Meadow Lakes Golf Club in Statesboro, Arthur Davis; Port Armour Club on Lake Oconee, Bob Cupp; Whitewater Country Club in Fayetteville, Arnold Palmer; Country Club of the South in Alpharetta, Jack Nicklaus; Jennings Mill Country Club in Athens, Bob Cupp; Atlanta National in Alpharetta, Pete Dye and P.B. Dye; Polo Golf & Country Club in Cumming, Joe Lee; Settindown Creek in Woodstock, Bob Cupp; Chateau Elan Golf Club in Braselton, Dennis Griffiths; and Eagle's Landing in Stockbridge, Tom Fazio. As can be seen by the names of the course designers, Georgia was adding quality as well as to the quantity of courses.

The GSGA added staff to accommodate for more member clubs and added services. Layne Williams came to the GSGA in 1987 to conduct state competitions. Now senior director of rules and competitions for the organization, Layne is the official

in charge at all GSGA competitions and USGA qualifiers held in Georgia, helps plan and execute all competitions and conducts rules seminars for clubs across the state.

As Layne says, he is "in the book" every day—meaning the *Rules of Golf*, as established by the USGA and the R&A. It would be an interesting calculation to estimate how many rulings Layne has made in nearly thirty years of handling competitions. The total would be in the thousands. Layne has also worked rules at the national level. He has served many times at U.S. Opens and U.S. Amateurs and at the U.S. Mid-Amateur.

He is credited with establishing the first golf team at LaGrange College during his sophomore year. He won the club championship at Highland Country Club in La Grange, putting him in the company of fellow champions Ely Callaway and Allen Doyle.

In addition to the State Amateur Championship, the GSGA now annually conducts seventeen other statewide competitions for men and women of all age groups and skill levels, four interstate matches, a summer-long junior sectional program and nearly thirty-five local and sectional qualifying events for both GSGA and USGA championships. Williams has a role in all of these events.

Opposite: White Columns #8.

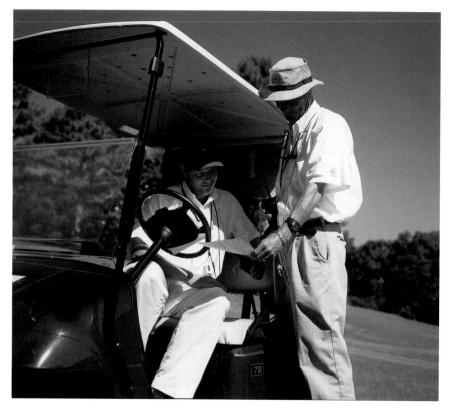

Mike Davis and Layne Williams.

Steve Mona, who became the GSGA's executive director in 1983, stayed for ten years and helped the GSGA in its transition to ownership of its own building and the addition of new services for member clubs. In November 1993, Mona became the chief executive officer of the Golf Course Superintendents Association of America, which he held until March 2008, when he assumed his role as chief executive officer of the World Golf Foundation. In the fall 2013 issue of *Golf Inc.*, Mona was selected to the magazine's "Most Powerful People in Golf" list for the thirteenth consecutive year. In 1999, *Golf Digest* listed Mona as one of the golf industry's "Most Powerful People in Golf."

Louis Brown, who had finished second in the State Amateur in 1982 and 1984, finally broke through for a

Bill Ploeger.

victory in the 1985 Championship. At age twelve, Brown won the eleven-to-twelve age division at the Southern Junior Invitational in Pensacola, Florida. The following year, he captured the first of four Wilkins Kirby Championships.

By 1982, he was ranked sixth on *Golf Digest*'s list of top U.S. junior players. At the collegiate level, he captained Georgia's 1984–85 golf team while being named All-SEC twice. His more recent wins included the 1997 Georgia Open, the 1998 Atlanta Open and the GSGA's Four Ball in 2008.

The Farm opened for limited play on May 1, 1988. Robert E. Shaw of Georgia's Shaw Industries initiated the project, purchasing the land for the course in 1984. By 1985, course designer Tom Fazio was well underway at creating a course that would immediately attract competitions. In 1989, the Carpet Capital Collegiate Classic took place at the Farm, with David Duval, then a member of the Georgia Tech golf team, participating. Jim Furyk, who played for the University of Arizona, competed in the event in 1990 and 1991, later winning the U.S. Open in 2003. In 1990, the club hosted the State Amateur Championship, which was the year Allen Doyle won his record sixth title. Three years later, Doyle would finish runner-up to Justin Leonard when the Farm hosted the Southern Amateur Championship. Leonard won by a nine-stroke margin. That same year, Bill Ploeger, then the current USGA Senior Amateur Champion, won the State Senior Amateur at the course.

Nearly one hundred years ago, the land now known as Reynolds Lake Oconee was established as a family hunting and fishing retreat. Originally known as "Linger Longer," the decision was made to develop the land as a golf course home community. Today, the development features six golf courses, each designed by a notable designer; restaurants; swimming pools; pedestrian trails; marinas; a tennis center; and more, all surrounded by Lake Oconee. Reynolds is also home to The Ritz-Carlton Lodge, a 251-room lakefront resort and spa, which earned 2013 AAA Five Diamond Hotel and 2013 Forbes Travel Guide Four-Star Awards.

Reynolds Lake Oconee features 117 holes of championship golf from designers Bob Cupp, Jack Nicklaus, Tom Fazio, Rees

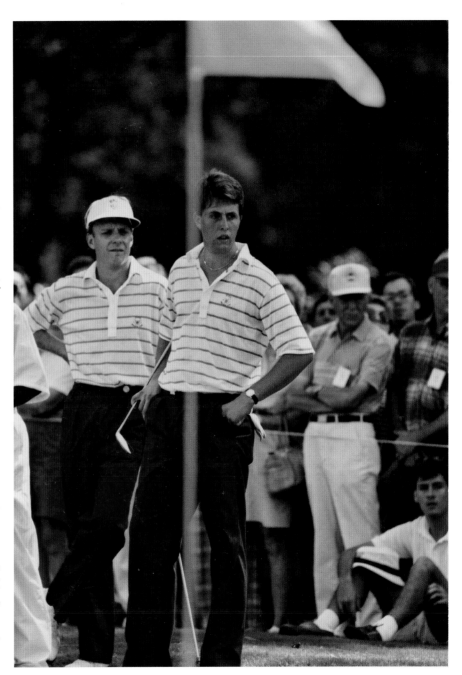

Danny Yates with Phil Michelson at the Walker Cup at Peachtree Golf Club in 1989.

Jones and Jim Engh. Reynolds is also home to the Reynolds Golf Academy, as well as the TaylorMade Kingdom.

Under new ownership since August 2012, the Reynolds golf resources continue to win acclaim. The Great Waters course was included on the exclusive rankings in *Golf* magazine as one of the "Top Five Favorite Nicklaus Courses You Can Play." In ranking Great Waters with Cabo del Sol Ocean Course (#1, Mexico), Cap Cana Resort (#2, Dominican Republic), Spring City & Lake Resort (#3, China) and the Challenge at Manele (#4, Lanai), the Reynolds Great Waters course is the number one Nicklaus course in the continental United States on this list.

Since 1991, Laura Coble's name has been inscribed at the top of state championship trophies more than twenty-five times. Among these titles are multiple wins in the Greater Atlanta Women's Amateur (a statewide event), the GSGA Top 40, the Georgia Women's Open and the GSGA Women's Team Championship. She has also represented her state eighteen times in the Georgia-Florida (now Southeastern Women's Challenge) Matches.

In 2012, she won the Georgia State Golf Association's Women's Match Play Championship for a record ninth time; won the Georgia Women's Amateur Championship, conducted by the Georgia Women's Golf Association, for the sixth time; and advanced to the semifinals of the U.S. Women's Mid-Amateur Championship. All of this earned her the 2012 GSGA's Women's Player of the Year honors for the fourteenth time in fifteen years.

Besides her Women's Player of the Year awards, Coble is the only golfer to have won the coveted Tommy Barnes Award as overall GSGA Player of the Year three times. She was the first female winner in 2000, claimed it again in 2005 and shared the award with her USGA State Team Champion mates, Dori Carter and Mariah Stackhouse, in 2009. On the national scene, she holds the record as the only player to have participated on three USGA State Team Champion teams, in 2005, 2009 and 2011, with a different set of partners each time.

Coble's success outside Georgia also includes having qualified for the U.S. Women's Open in 2001; participation in two LPGA events, the 2001 Asahi Ryokykun Invitational in North Augusta and the 2005 Chick-fil-A Charity Championship in Stockbridge; a win in the prestigious Women's Southern Amateur in 2005; and earning her way to the quarterfinal round of the U.S. Women's Mid-Amateur four times, in 2005, 2006, 2010 and 2011.

A native of Augusta, Larry Mize sank one of the most improbable shots in golf history to win the 1987 Masters Tournament. Tied with Seve Ballesteros and Greg Norman after four rounds, in the sudden-death playoff Ballesteros was eliminated after the first hole, which began on the tenth hole. Mize's second shot on number eleven landed to the right of the green, a distance of 140 feet from the hole. Norman was on the green in two with a possible birdie putt. Mize next broke Norman's heart by sinking a

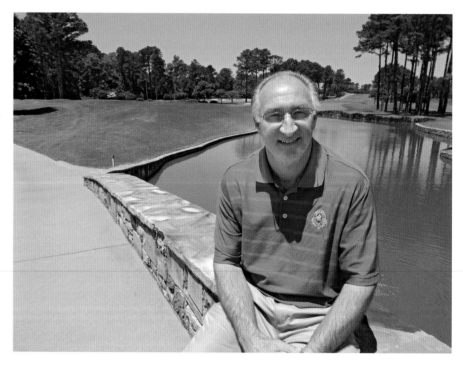

Ken Mangum, former director of golf courses and grounds at Atlanta Athletic Club, assisted the club with hosting several major events during his career. Chris Borders, general manager during that era, and Rick Anderson, director of golf, also played key roles for the events.

The Frog Golf Club at the Georgian.

sand wedge shot for a birdie. Norman missed his putt, and Mize, who had worked on the scoreboard at Augusta National's third hole as a teenager, won the tournament. He finished in a tie for fourth at the U.S. Open that June.

Mize attended Georgia Tech and turned professional in 1980. He finished in the top 125 on the money list (the level needed to retain membership on the PGA Tour) for twenty seasons from 1982 to 2001. His first PGA Tour win was the 1983 Danny Thomas Memphis Classic.

Ray Cutright started as director of golf at Idle Hour Country Club in 1993, after a series of positions in golf management. A longtime member of the PGA of America, Cutright served as vice-president before working his way up to president of the Georgia Section in 1996 and 1997 and honorary president in

1998 and 1999. He served as a District 13 director of the PGA of America from 2008 to 2010. He is an original staff member of the Golf Professional Training Program and has taught more than fifty workshops and seminars for the PGA, its sections and chapters since 1979. In 2014, he was named PGA of America Professional of the Year.

Mike Waldron became executive director of the GSGA in 1994. When Waldron, an Atlanta native, took over at the GSGA, it comprised more than 355 golf clubs and courses and eighty thousand individuals in Georgia. More than three hundred volunteers supported the activities of a staff of fifteen. Waldron had worked in the golf tournament and administration business since 1979, including nine years with the LPGA and one year with the USGA. Prior to becoming executive director, Waldron was a volunteer member of the GSGA Board of Directors from 1978 to 1993. After leaving the GSGA in 2013, he returned to tournament management for the LPGA. In recognition of his services to golf, the International Association of Golf Administrators (IAGA) in 2015 selected Waldron as the twenty-first recipient of the IAGA Distinguished Service Award.

While serving with the GSGA, he was named president of the IAGA for 2003 and a member of the Georgia Junior Golf Foundation Board of Directors. His other affiliations included the LPGA Tour Hall of Fame Veterans Committee, the World Golf Hall of Fame Advisory Committee, the Golf 2020 State Alliance Task Force, the USGA Handicap Procedure and Regional Associations committees and the Georgia Golf Hall of Fame Nominating Committee.

The Standard Club golf course, which opened for play on its present site in 1987, began a major new chapter in its history in 2004. Renovations, directed by Michael Riley Design, LLC, began that May, and golfers were back out on the greens in late spring 2005. Immediate validation of the quality of the renovation work came when the USGA selected the Standard Club to host a July 2006 qualifying round for the 2006 U.S. Amateur Championship.

"Mike Riley demonstrated that he has a good understanding of the core values in golf," said Jeff Kerker, Standard Club president at the time of the renovation. "He has an ability to create a challenging but fair golf course that can be enjoyed by golfers of every level."

The Standard Club is known for a long list of members who are strong competitive golfers. As a junior golfer, club member Jerry Greenbaum won the International Jaycee Amateur in the 1950s. He has played in the USGA Amateur four times, and he finished third low amateur in the 1964 U.S. Open at Congressional. Greenbaum stayed away from tournament golf for sixteen years because of business commitments, but when he returned to competition, he became one of the country's best senior golfers, winning nineteen events and qualifying for many USGA events, including two USGA Mid-Amateurs. In addition, he was runner-up in the 1999 British Senior Amateur.

Through its predecessor, the Concordia Association, the Standard Club traces its history back to 1866. Several Atlanta in-town buildings housed the activities of the club during its history prior to its first site with a golf course. The Standard Club's first golf course, built in 1949 on a site adjacent to Roxboro Road in Buckhead, had originally been routed by Robert Trent Jones Sr. when Peachtree Golf Club considered the site for its course. Peachtree decided on a tract of land farther north, and the Standard Club built facilities—including a clubhouse, swimming pool and tennis courts—on the Roxboro Road site. In 1983, the club directors determined it would be in the best interest of the club to relocate farther north, and they opened the new club in 1987.

In 2000, at the fifth anniversary of the opening of White Columns Golf Club, golf course designer Tom Fazio was asked about what had changed the most in the development of courses during his career. "It's underground," replied Fazio. "We know more about agronomy, drainage, irrigation, bunker construction, maintenance and every other aspect of course construction and conditioning. The result is a golf course today that provides a better playing surface even under difficult weather circumstances, whether it's high heat or heavy rain."

Soon after White Columns opened in 1995, it attained a rating as the state's best daily fee course. The invisible,

GOLF AS A COLLECTOR'S ART

Wayne Aaron of Atlanta has become one of the most knowledgeable collectors in the world of golf's historic memorabilia and artwork. Wayne not only acquired an outstanding collection of golf art, some of which now resides at Cherokee Country Club in Atlanta, but he has also served as a resource for the Georgia State Golf Association and the United States Golf Association in their efforts to preserve the history of the game.

A forty-five-year career of senior management in business provided Wayne with the resources to invest in golf art and collectibles. He was also a founding sponsor of the PGA World Golf Hall of Fame, a founding member/partner of Secession National Golf Club and a member of the Pinehurst Golf Club. Additionally, he is a member of the Donald Ross Society, the Tillinghast Society, the Seth Rayner Society, the British Golf Collector's Society and the Golf Collectors Society (USA). He serves on the board of directors of the Bob Jones Foundation, and he has been a consultant to the Gene Sarazen Foundation, Sea Island Corporation, Atlanta History Center, Cherokee Town & Country Club, Atlanta Athletic Club, Castle Pines Golf Club and Royal Blackheath Golf Club (London, England).

Wayne began his collecting journey forty years ago. His wife, Claudia, has been part of the quest for nearly all of that time, and she shares Wayne's love for golf and its history, having herself won hickory-shaft ladies tournaments in the United States and the United Kingdom. Their home has most of their large golf collection on display. The Golf Collectors Society identifies forty-four categories of collecting interests, and the Aarons dedicate themselves to more than a dozen of those categories in their own collection.

"We have had one guiding principle in our collecting activity," says Wayne. "Ray Fores Davis advised me to focus on quality of items, not quantity. In order to appreciate which were the quality items in any category of collecting, it became imperative to educate myself about the history of golf and its implements and other artifacts associated with the game."

To that purpose of education in golf, Wayne has assembled a library of books totaling more than five thousand. Wayne has shared his knowledge about the values of golf collectibles and the history of the game, including advising his own home club, Cherokee in Atlanta, on developing its own collection of golf art. The club's walls are adorned with some of the finest examples of golf art to be found anywhere. The club also displays many pieces that honor the career of Louise Suggs, a Georgia native and LPGA founding member.

Jim Apfelbaum, the former editor of the GCS Bulletin, the Golf Collectors Society magazine, has some tips for anyone getting interested in collecting golf memorabilia. "The best advice I got from the early collectors was to determine my interest before opening my wallet, be it putters, stamps, cigarette cards, books, tees, et cetera," Jim suggests. "I remember being shown photos of boxes and boxes of stored clubs that were purchased indiscriminately and without affection by early collectors. These gather dust. Better to pick an area that brings joy."

Wayne advises that an interest in golf collectibles should govern anyone's investment in the area. "Valuations change over the years as they do with anything, whether its paintings, furniture or golf collectibles," says Wayne. "No one should anticipate that a modest investment in a golf collectible will result in a windfall somewhere down the road. The experts have been there searching for the truly valuable items before you for many years. An enjoyment in owning a significant piece of golf's history should be a sufficient reward from collecting, not any return on investment."

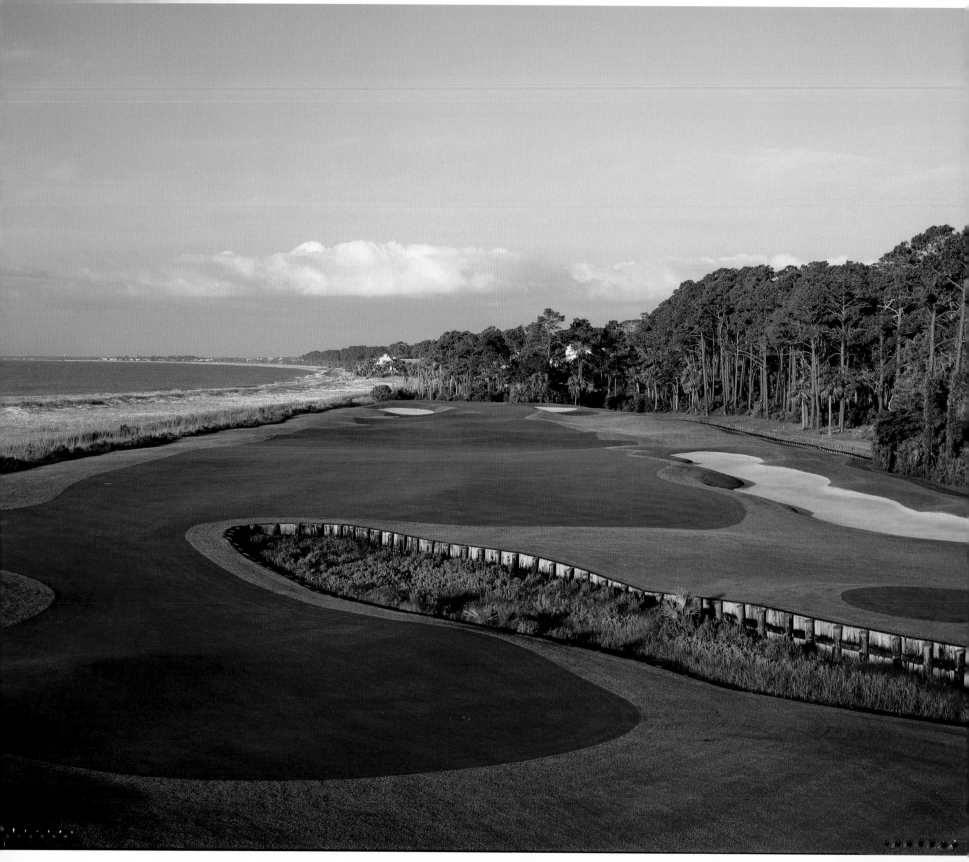

underground aspects of the construction of a course rarely enter into rankings, but Tom Fazio's appreciation for every element in the creation of an enjoyable layout contributes to his reputation as among the best architects in golf. That the course has hosted qualifiers for the U.S. Amateur and U.S. Mid-Amateur and a variety of other competitions justifies the high esteem in which it is held.

The director of instruction at the now private White Columns is Cody Barden, a regularly featured instructor on the Golf Channel's *Academy Live* program. Among Barden's celebrity golf students are Chris Doleman, former NFL star; Jim Courier, U.S. Open tennis champion; David Morse, actor; and Mike Mills of the rock group REM. During his career, Barden coached four individual State Amateur champions, a U.S. Walker Cup player, five Nationwide Tour players and players on the PGA, LPGA and Champions Tours.

Barden has taught juniors as young as age five and also coached the Pepperdine University men's golf team to a national NCAA Championship. Thirty of his students have earned college scholarships; eight students were selected Collegiate All-Americans and three to the All-Nicklaus Team; one student was selected for the Walker Cup (United States); and one student was selected for the World Amateur Team (China). Nine of his students have won State Amateur Championships. As much as he demands from the juniors he teaches, he still advocates making learning golf a fun experience.

"One of our best events at White Columns is our parent/junior tournaments," said Barden. "The kids like playing with their parent, and we even allow a guest of the junior to participate if they want. We also work on activities in our juniors program that are athletic like balancing, striking and movement that contribute to success in any sport and just overall physical development."

East Lake Golf Club had enjoyed a long and glorious history prior to the 1990s. The young Bobby Jones had learned the game there while growing up in a home across the street from the club. It hosted many significant events,

Gene McClure, president of the GSGA in 1996 and 1997.

including the 1963 Ryder Cup. By the 1970s, though, the neighborhood had begun to deteriorate. The golf club lost members when Atlanta Athletic Club relocated to a site in Duluth, north of Atlanta, and there was little appeal for golfers to join a club in a difficult in-town neighborhood.

"You don't change a community just by building nice houses," said Tom Cousins, who applied his vision and business acumen in initiating the redevelopment of East Lake in 1991. "You have to provide people with a new way of life."

Having founded Cousins Properties in 1958, Tom Cousins contributed to the growth Atlanta experienced during the 1960s and '70s. Some of the company's projects included golf course home communities, among them Indian Hills, Hidden Hills and Big Canoe. The company also built the Omni Coliseum, home to the Atlanta Hawks, One Ninety One Peachtree Tower and Wildwood Office Park. Cousins Properties eventually became one of the most successful equity Real Estate Investment Trusts (REIT) in the nation.

In 1991, the Cousins Foundation began the revitalization of the East Lake neighborhood. It was not until two years later that East Lake Golf Club came on the market, and its renovation appealed to many because it could generate jobs

Opposite: Ocean Forest.

TPC Sugarloaf.

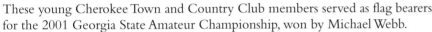

These young Cherokee Town and Country Club members served as flag bearers for the 2001 Georgia State Amateur Championship, won by Michael Webb.

Davis Love III.

for the surrounding community. East Lake Golf Club was a beneficiary of the overall mission to redevelop the East Lake community.

"Our interest in the East Lake community started long before the East Lake Golf Club became available," said Cousins. "Our family foundation had been funding groups in the community for several years and then decided that we could do more good if we came out here ourselves. When the East Lake Golf Club became available, we thought we could restore it to its former glory and create jobs and income for the community. Then, we got really excited about its place in history." Golf course architect Rees Jones did the renovation of the golf course and, upon reopening it, drew immediate acclaim. The club subsequently hosted the U.S. Amateur Championship and the PGA Tour Championship, which, starting in 2004, became an annual event there.

The enhancement of East Lake Golf Club has helped fund the redevelopment of the community, which may be the first time in the United States that golf has had such a direct economic impact. Corporate members of the club have contributed more than $20 million toward the revitalization of the East Lake neighborhood. Each corporate membership of $275,000 contributes $200,000 to the nonprofit organization responsible for the community redevelopment. Among the corporate members are Home Depot, American Express, AT&T and Coca-Cola.

When East Lake Golf Club hosts the PGA Tour Championship, proceeds directly benefit the East Lake Community Foundation and the First Tee program, which helps involve disadvantaged youth in golf. While the renovation of East Lake Golf Club was not an original goal in redeveloping the community, the financial support to the community has been a critical component of the program's success. The club's caddie program has employed more than four hundred local high school and college students, and twenty caddie college scholarships have been awarded over the last five years.

Above: The Atlanta History Center has a permanent Bobby Jones exhibit.

Right: Ansley Golf Club's Settindown Creek course.

East Lake Golf Club is not the only golf element in the community's redevelopment. Charlie Yates Golf Course, now a nine-hole course, built across the street from East lake Golf Club, hosts the East Lake Junior Golf Academy. This is a cornerstone program of the foundation that teaches golf skills and life lessons to neighborhood children. The academy provides year-round golf instruction, equipment, golf and tournament play opportunities and mentoring for more than seven hundred inner-city children. All children who participate in the academy can play golf for free at the Charlie Yates Golf Course. The academy utilizes the values of the game of golf—integrity, perseverance, patience and discipline—to teach larger life lessons.

Recognizing the importance of education in the community, the foundation created an "Educational Village" in the middle of the Villages of East Lake, including a new elementary school (Drew Charter School), a new state-of-

The 2004 Curtis Cup team, with captain Martha Kirouac directly behind the trophy.

the-art YMCA, a child development center and, recently, a new high school. The Educational Village was paid for with donations from corporations, foundations and individuals.

What has been accomplished in the East Lake community has become a paradigm for inner-city redevelopment nationally. "Over one thousand people visit the Villages of East Lake annually," said Cousins.

> *Most of those visitors come hoping to be able to replicate all or parts of what we have done in their own communities. Some of those visitors were blinded by the grandeur of the East Lake Golf Club and didn't see how they could do the same kind of thing since their neighborhood didn't have a historic old golf course. When we explain to them that the East Lake Golf Club, while a wonderful resource, was not necessary for the other parts of the revitalization, they start to understand that they can put together a similar project that can work in their neighborhood. Every neighborhood has assets that can be used to generate excitement about change. The trick is to figure out how to leverage those assets.*

In 2000, Stephen Keppler began as the PGA director of golf at Marietta Country Club. Born in London, England, Keppler represented his home country at all levels of amateur golf. He was a member of the 1983 Great Britain and Ireland Walker Cup team. He came to the United States to attend college, playing on the golf team at Florida State University. He was named an All-American during his time in Tallahassee.

During his time in Georgia, Keppler has compiled an impressive collection of Georgia PGA Section victories and honors. Starting with the 1988 Georgia PGA Assistants' Championship, Keppler owns fifteen tournament titles. His accomplishments earned him the Georgia PGA Player of the Year award for four straight years from 1993 to 1996.

On the national scene, Keppler has played in four PGA Championships and thirteen PGA Professional National Championships, with his best finish a tie for eighth in both 1996 and '98. Keppler has played in twelve PGA Tour events. His best showing, a tie for third at the 1995 BellSouth Classic at Atlanta Country Club, was the highest finish by a club professional in the modern era of the PGA Tour. Through the 1950s, nearly every golfer on the PGA Tour also had a club professional affiliation.

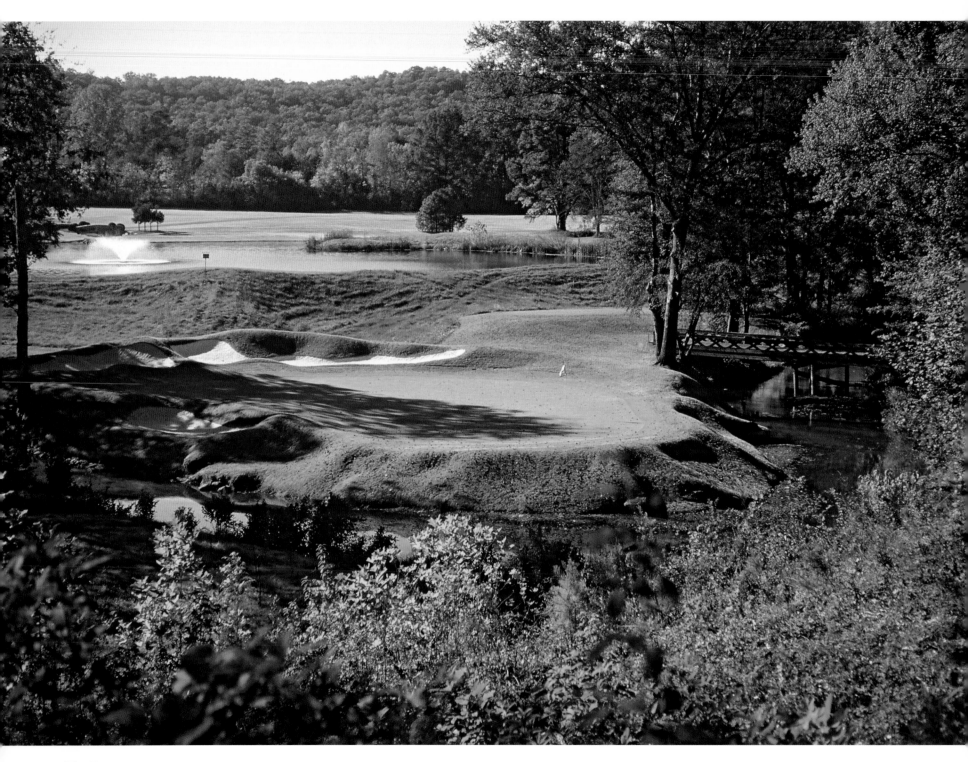

The Farm.

NOW AND THE FUTURE

2005–2015

Given the nature of amateur golf in the current era, the winners of the State Amateur Championship in Georgia, who are always among the best players in the nation, frequently go on to professional golf careers. Brian Harman of Savannah, who won the State Amateur in 2005, went on to play on the PGA Tour, as did Harris English of Thomasville, the 2007 champion, and Russell Henley of Macon, who won in both 2008 and 2009. David Noll Jr. won for the second time in 2011, with his first victory coming in 2003. Noll finished second in 2005, 2009 and 2012. Bookending Noll's win in 2011, Lee Knox of Augusta won in 2010 and 2012.

The offspring of some of Georgia's most accomplished golfers are now making their marks. Robert Mize, son of Masters champion Larry Mize, won in 2014. Dru Love, the son of Davis Love III, won in 2015. Dru, whose full name is Davis Love IV, goes by Dru as an abbreviation of "Quadruple." Dru, whose grandfather was Davis Love Jr., is continuing a golf dynasty in Georgia.

Georgian golfers have continued to win at the national level. Allen Doyle won the U.S. Senior Open in 2005 and 2006. Dave Womack won the 2006 U.S. Mid-Amateur Championship. Andy Shim won the 2012 U.S. Junior Championship. At the other end of the age spectrum, Doug Hanzel won the U.S. Senior Amateur Championship in 2013. Another Georgian, Rinko Mitsunaga, teamed with Mika Liu, from California, to win the U.S. Women's Four-Ball Championship in 2015. The two teenagers knew each other from attending the IMG Academy in Bradenton, Florida.

The locally grown talent in Georgia points out the success of the junior programs that are developing the golfers. How early should a child be introduced to the game? Bob Jones began at age five. A neighbor who was a member at the East Lake course of the Atlanta Athletic Club allowed Bob to take a few swings with a driving iron—or cleek, as it was known in 1907. Bob and a friend soon laid out a five-hole course in the front yard of the Jones family home. By age six, he was observing the club's pro, Stewart Maiden, when he played the East Lake course. Within eight years, Jones progressed to winning the first Georgia State Amateur Championship (1916) and being invited to the USGA Amateur Championship that same year.

For most children at age five or six, attention span is limited, and incessant drills soon become tiresome. Teaching professionals structure golf schools for the youngest students so that each drill or activity lasts not much more than fifteen minutes. When the juniors are taken to the course to play a few holes to perform what they've learned, that is exactly what they play: three holes. An entire practice session for the youngest golfers might last only thirty minutes. For older children who can tolerate a little more continuity, the number of holes is extended. Yet introducing even an older child to the game should be a gradual process.

Margaret Shirley, winner of the 2014 U.S. Women's Mid-Amateur Championship.

TopGolf is a rapidly growing set of golf game sites that use microchip technology inside golf balls that are shot into several targets with real clubs to score points. Players tee off from a driving bay onto a landscaped outfield with targets ranging in distance from 20 to 215 yards. Players receive instant feedback on how far they've hit a shot and are allocated points based on distance and accuracy.

Introducing a child to golf while on vacation is an excellent idea. Golf as part of a series of fun activities, especially shared with other family members, can be engaging to a child. Before even taking a junior to a golf course, there are some ways to see whether there is any interest in the game. First, take the child to a golf tournament or watch golf on TV. Miniature golf is entertaining and a good introduction to the game without the pressure that comes with participating in a clinic or golf camp. Taking a junior to the driving range and letting him or her hit a few balls is another option.

Schools have traditionally not been the places where a junior will be introduced to golf, but that is changing. One productive program is TGA Premier Junior Golf, launched at six Los Angeles schools in the fall of 2003. There are now fifty TGA programs across the United States, with several in the Atlanta area serving over five hundred children. SNAG is another program conceived to introduce juniors to golf. It stands for "Starting New at Golf." SNAG falls somewhere between miniature golf and regulation golf, allowing for full shots, pitching, chipping and putting. Any age group can play. The game has its own simplified rules and terminology.

SNAG has only two golf clubs: the Launcher is used to launch, pitch and chip the ball; like a putter, the Roller is used to roll the ball toward the target. All shots other than rolling (putting) are played off of a mat and tee called the Launch Pad. This ensures that the player will have an optimal lie every time. The target, called a Flagsticky, also differs from anything else in golf, as it is not a hole with a cup inside but rather an above-ground weighted cylinder covered with a hook material. The SNAG ball is slightly

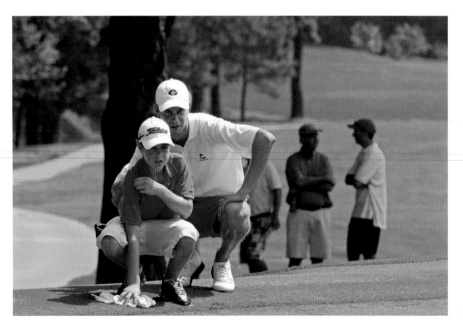

Harris English (rear) with his young caddie.

Lee Knox of Augusta (left) won the Georgia State Amateur Championship in 2010 and 2012. He is shown with his father, Jeff Knox, who finished as runner-up in the State Amateur in 2006 and tied for runner-up in 1998 and 2007.

Right: Russell Henley.

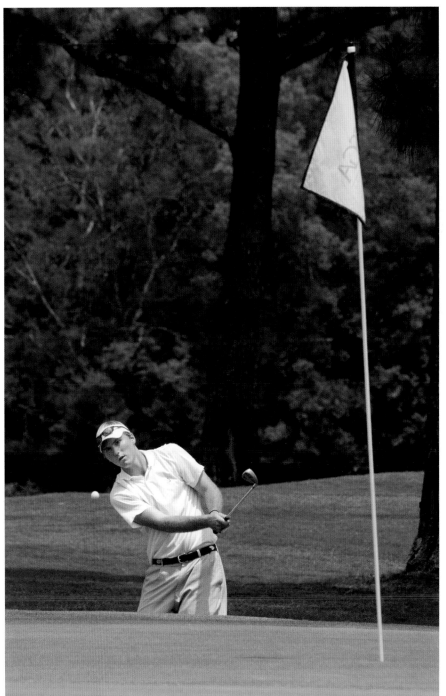

smaller than a tennis ball and is covered with a loop material. Unlike golf, where you finish by putting your ball into the cup, in SNAG, you finish by sticking your ball to the Flagsticky. Because of the mobile Launch Pad and Flagsticky, SNAG is portable and playable just about anywhere.

Another aspect of beginning in golf is learning the rules and the etiquette, which is as true for juniors as it is for seniors. All golfers play by the same rules—an element of the game that most avid golfers cherish. There are several books that discuss the rules of golf in a simplified manner, including with illustrations or photos to depict different circumstances on the golf course. The youngest juniors may need assistance understanding the rules and the etiquette, but it is never too early to get a golfer to appreciate them.

Introducing a child early to golf can lead to a lifetime of enjoyment.

Playing partners will tolerate wild hooks, chunked chip shots and even four-putts on the green, but talking during someone's backswing or deliberately moving a ball from a bad lie may not be acceptable to those who do adhere to the rules.

If a junior does show aptitude at golf and wants to play competitive golf, there are plenty of opportunities in Georgia. The Atlanta Junior Golf Association conducts between 110 and 120 events a year around twenty-six North Georgia counties, including in Rome and Athens. A new development is allowing juniors to just come and play golf at a session monitored and managed by the AJG. The organization is also beginning to emphasize team-oriented competitions as opposed to individual stroke play.

Georgia is fortunate to have several city programs that support junior golf. Athens, Atlanta, Augusta, Columbus, Rome, and Savannah all have junior golf associations conducting tournaments and learning clinics. A comprehensive list of useful links is on the gsga.org website.

The Drive, Chip & Putt competition finals are now held annually at Augusta National Golf Club.

Capital City Club's Crabapple hole #4. The course will host the 2017 U.S. Men's Mid-Amateur Championship, with qualifying rounds shared with Atlanta National.

One player exemplifies how well Georgia is developing its junior talent. Born in 1994, Mariah Stackhouse of Riverdale started in golf at age two. Her family moved from Charlotte to Georgia when she was four. By age six, she had begun tournament play. Out of the 188 tournaments in which she competed by age twenty-one, she accomplished top-ten finishes 169 times. Out of those 188 tournaments entered, she won 97, a better than 50 percent winning percentage. Just a few of her wins have included the AJGA Junior at Steelwood, 2011; PGA Georgia Women's Open Champion, 2009; Georgia 4A High School Individual Champion, 2009; Georgia Women's Amateur Championship, 2008 and 2009; GSGA Women's Match Play Championship, 2007 and 2008; Georgia State Golf Association Girls' Champion, 2007 and 2008; and Atlanta Junior Golf Association Grand Champion, 2007. She also participated on the winning Georgia team for the 2009 USGA Women's State Team Championship.

Among her records are Youngest PGA Georgia Women's Champion, 2009; Southeastern Junior Golf Overall Girl's Single Round Record, 65 (7 under par), June 2007; and Youngest Winner/Finalist, Georgia State Women's Match Play Championship, 2007. For her accomplishments, she has attained significant recognition, including AJGA All-American, First Team, 2011; GSGA Girl's Player of the Year, 2007, 2008, 2009 and 2010; GSGA Tommy Barnes Award 2009 (shared with Laura Coble and Dori Carter), which is given to the best overall player of the year in all categories; and GSGA Women's Player of the Year, 2008. Despite her commitment to golf, Mariah has achieved high academic standards, resulting in a scholarship to Stanford University, where she is a member of the golf team. 077

At twelve, Stackhouse qualified for her first U.S. Girls' Junior at Carmel Country Club in Charlotte, North Carolina. While her results weren't all she wished for in that event, her coach, Chan Reeves of the Atlanta Athletic Club, was impressed by how she handled the experience.

"This is my favorite Mariah Stackhouse story," said Reeves. "When she came back, I asked her what the coolest thing was about the event. I thought it would be seeing her name on the

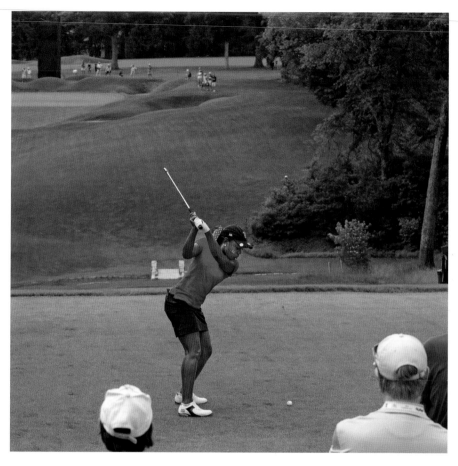

Mariah Stackhouse.

caddie bib or numerous things you could come up with. She said the coolest thing is you can go in the locker room and get as many ice creams as you wanted. I looked at her and said, 'You actually get it.' That's pretty good for a twelve-year-old."

In her freshman year at Stanford, Stackhouse carded a school—and NCAA—record 61 in the final round of Stanford's Peg Barnard Invitational on the school's course designed by George Thomas, the same designer who did Riviera and Los Angeles Country Club's North course. On the outward nine, she shot a 9-under-par 26 (that is not a typographical error; she shot a 26 for nine holes).

Stackhouse thus earned an invitation to play on the U.S. 2014 Curtis Team, becoming the first African American to be named to a USA Curtis Cup Team. "To be the first African American on the Curtis Cup Team is amazing," said Stackhouse, who in her sophomore year became a first-team All-American. "I don't look at myself as a trailblazer. But I think that it is really cool."

She contributed in the Curtis Cup by achieving a two wins, no losses and two halves record. On Day 1, in the morning four balls, Stackhouse and partner Emma Talley defeated Stephanie Meadow/Georgia Hall of the Great Britain team, 2 and 1. On Day 2, Stackhouse again partnered with Emma Talley to defeat Gabriella Cowley/Gemma Dryburgh of the GBI team. In the afternoon foursomes on Day 2, Stephanie Meadow/Georgia Hall, of GBI, halved with Ally McDonald/Mariah Stackhouse. On Day 3, in singles matches, Eilidh Briggs of the GBI team halved with Stackhouse.

Another upcoming junior talent is Alexander Derosa, who grew up playing at Capital City Club and on the Lovett golf team. A winner of the 2014 Southern Junior Golf Tour Vestavia Junior Classic in Birmingham, Derosa shot 70/64 to earn the win. He also won when the Southern Junior Golf Tour came to his home club in October that year, finishing first among fifty-nine competitors. Along with other great performances, his play during that year earned him the 2014 Player of the Year awarded by the Southeast Junior Golf Tour in December of that year. He participated on the 2015 GHSA State Tournament Champion team at the Lovett School.

One junior player had a dream come true early in his experience as a golfer. Told by his father and grandfather in March 2006, when Preston Heyward was eleven, that they were going to Augusta for a round of golf, Preston thought they would be playing Augusta Country Club. But when they arrived at Augusta CC, they were told that their host wasn't there. They retreated to an IHOP nearby to consider their options.

Preston began playing golf when his father gave him a child's plastic club when he was age two. At about age six,

The 2009 Georgia Women's USGA State Team champions (captain Sissi Gann, Laura Coble, Mariah Stackhouse and Dori Carter). Georgia has won four of these championships, including in 2015.

he graduated to playing the par 3 course at Atlanta Athletic Club with his father. Within a few years, he had made five holes-in-one at the par 3 course at the AAC and another at St. Ives. In August 2005, Preston won the Georgia U.S. Kids championship for ten-year-olds. That qualified him to play in an international-level competition sponsored by U.S. Kids at Ford's Colony in Williamsburg, Virginia, where he finished respectably in the event.

His grandfather Sam Kiker thought that Preston would enjoy playing Augusta National, where he knew a member that could host Sam, Kin Heyward, Preston's father and Preston. After the short break at the nearby IHOP, Sam made the suggestion that they try Augusta National. When they drove up to the entrance, the guard peered into the car and said, "Aren't you Preston Heyward, the state champion?"

"Yes, sir," said the startled Preston, not realizing that his fame had reached Augusta.

Augusta State won the men's NCAA Division I Championship in 2010 and 2011.

When they arrived at the club house, their host, upon greeting them, said, "My regular Sunday group can't join me today, what about playing with me?" No problem.

"I was thrilled when I didn't top it on the first tee shot," Preston recalled with relief. "I was shaking, but I hit it near the fairway bunker on the right." Preston negotiated the par threes very well, parring holes four and six and then taking bogey on twelve and double bogey on sixteen after needing four putts. Once back in the clubhouse, another highlight of the day was trying on a green jacket, maybe a preview of a ceremony a few years or so away. Even if he eventually wins a Masters, the grass may never be greener than what he saw when he first set foot on the tee box on number one at Augusta National.

Tomorrow's golfers may just be picking up a golf club for the first time today. While the GSGA primarily supports golf as a sport, through the GSGA Foundation, the organization supports the educational development of deserving students throughout the state, employees of golf courses and family members of golf course employees. The foundation, the GSGA's charitable affiliate, uses contributions from individuals, corporations and the association for the following educational opportunities: Yates Scholarships, for employees or dependents of employees, at GSGA member clubs, and Moncrief Scholarships, for agronomy and turf grass management students at the University of Georgia and Abraham Baldwin Agricultural College.

Georgia's juniors benefit from access to many excellent instructors. Originally from Philadelphia, Pennsylvania, Gregg Wolff has been head golf professional at Willow Lake Golf Club in Metter since 1981. He has excelled as a teacher during his tenure at Willow Creek, being given the 1996 Georgia PGA Junior Golf Leader Award. While attending Georgia Southern, Gregg was a member of the nationally ranked men's golf team and received the NCAA Independent All-American honor in

1976. He has continued to compete throughout his career. Wolff and fellow Georgia Golf Hall of Fame member Dewitt Weaver Jr. are the only players to have captured all four of the Georgia PGA major championships: the 1984, 2003 Match Play; 1990 Atlanta Open; the 1991 Georgia Open; and the 1985, '87 and '88 Georgia PGA Championship. As a senior, Wolff qualified for the 2004 U.S. Senior Open and won the 2005 Georgia PGA Senior Club Professional Championship. In 2001, the Georgia PGA established an award in his honor, the Gregg Wolff Award, which will forever be awarded to the Georgia PGA member having the lowest stroke average each season.

Wolff was honored as the Georgia Professional of the Year in 1998. One of his students, Carolyn Hooks of Augusta, took her first golf lessons from Wolff when she was age forty after a lifetime of focusing on tennis. "Gregg is someone who in giving a golf lesson is on a mission, and he is as much of a cheerleader as he is a golf instructor," says Carolyn. "He can make you feel the golf swing, but more importantly, he instills in the people he works with his passion for the game, and that enthusiasm is inspiring." Carolyn must have listened well during her lessons, for she won the Highlands Country Club Women's Championship in 2013 in North Carolina, has finished second to Laura Cauble at Augusta Country Club's Women's Championship several times and has earned a seventh-place finish in the Georgia Women's Senior Championship.

One of the key services of the GSGA to member clubs is maintaining handicaps for golfers. Linda Sommers, senior director of handicapping for the GSGA, has been involved with handicap services for nearly thirty years. The existing handicap formula was introduced in 1976. In 1984, the GSGA began using the GHIN (Golf Handicap Information Network), followed in 1987 with use of the Slope System. The merit of maintaining a handicap is that it allows a golfer to assess his or her skill level on any given golf course in comparison to another player's ability, thus providing an opportunity for an even competition that otherwise would not be possible between competitors of varying ability. The system works so well that statistically it is almost impossible for a golfer with an accurate handicap to beat his or her index by six strokes in any given round. It does happen, but especially in a competition, golfers bettering the index of how they play at their best (a handicap is not an average of scores but more a reflection of how a golfer plays at his or her best) by six strokes should never happen. With the transition in 2009 to handicap revisions being provided on the first and fifteenth of every month, it is easy for a golfer to have an accurate reflection of how he or she is playing. Posting every score is the key to an accurate handicap.

In 2014, Matt Williams became the executive director of the GSGA. Matt came to the GSGA after serving several years as the executive director of the Kansas City Golf Association and, previously, the Sun Country Amateur Golf Association. Beyond being a good administrator, Matt established a reputation for being a formidable competitor at the national level, having competed in U.S. Amateurs and U.S. Mid-Amateurs, among many other tournaments.

Matt's perspective on golf has been shaped by his experience and service to the game throughout the country, and he sees a bright future for the GSGA as it prepares for the next one hundred years.

Brenda Pictor was selected as the Tommy Barnes Award winner, signifying the Georgia State Golf Association's overall player of the year, for 2010 and 2011.

GSGA Presidents

1916–23	Dr. J.A. Selden★
1924–33	Lowry Arnold, Atlanta★
1934–36	C. Veazey Rainwater, Atlanta★
1936–45	Fielding Wallace, Augusta★
1946–55	Hugh Carter, Atlanta★
1956–57	William H. Zimmerman, Columbus★
1958–59	Jennings B. Gordon, Rome★
1960–61	Arnold Blum, Macon
1962–63	John B. Ellis, Atlanta
1963–65	E.H. "Hoot" Gibson, Macon★
1966–67	Frank Hedrick, Albany★
1968–69	George "Buster" Horton, Rome★
1970–74	Henry H. Cobb, Jr., Athens★
1975–76	Pete Cox, Albany
1977–80	Edward T. Barnes, Jr., Rome
1981–83	Billy Peters, Blakely
1984–86	Wendell Couch, Conyers
1987–88	Eddie LeBaron, Atlanta★
1989–90	John D. Reynolds III, MD, Augusta
1991–92	L. Andy Bargeron, Chatsworth
1993–94	Robert R. Harlin, Atlanta★
1995	Bill Todd, Marietta★
1996–97	Gene B. McClure, Atlanta
1998–99	Jim Broadwell, St. Simons Island
2000–01	Bill Blalock, Atlanta
2002–04	W. Richard Wilson, Columbus
2005–06	Glenn Cornell, Lawrenceville
2007–08	Seth L. Knight III, Columbus
2009–10	Chris T. Cupit, Milton
2011–12	Greg Butterfield, Smyrna
2013–14	Chuck Palmer, Atlanta
2015–	Dave Ballard, Roswell

★deceased

"Sustaining the game we all enjoy is of paramount importance to all the various golf organizations," commented Williams. "More than ever before, there is a collective mission amongst the allied golf groups to create a thriving sport that includes more girls and women, minorities and those with physical challenges."

"I believe we will continue to see a shift in how golf courses are being owned and managed," said Williams. "The trend toward corporate management groups owning and operating many golf courses over a broad geography, such as ClubCorp's presence in Georgia, will become more prominent in the future. Either through ownership groups or interclub collaboration, clubs will band together to develop economies of scale, develop expertise and spread resources to generate success. The GSGA will continue to play a prominent role in helping these facilities improve the experience of golfers for generations to come."

Although he is a relative newcomer to Georgia, Williams has a good appreciation of the state's importance in golf:

There is no doubt in my mind that Georgia will remain a national and international leader in golf. It will continue to produce champion golfers, host championship events, enjoy the benefits of a strong golf industry and serve as an example of how golf can improve the lives of everyone who plays the game. Georgia will continue to shape the history of golf.

Golf in Georgia has grown from a casual entertainment limited to a few participants to being a compelling recreational activity and an important industry since its introduction to the state over 220 years ago. The services provided by today's GSGA, 100 years after staging the first State Amateur Championship—such as handicapping, course rating and measuring, speaker service and scholarship programs—are logical extensions of the association's original concept. As the GSGA enters its next 100 years, the scale of the economic importance of golf in Georgia and the number of golfers continues to grow. Yet much of the original concept remains

Laura Coble.

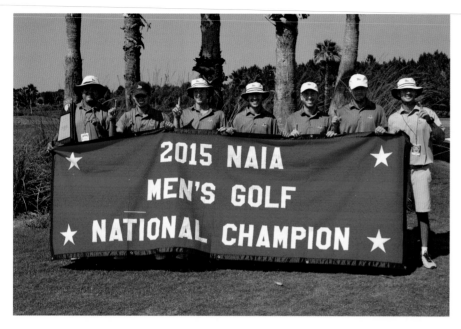

The College of Coastal Georgia won the 2014 and 2015 NAIA Men's National Championships. Coach Mike Cook was NAIA Coach of the Year in 2014 and 2015.

the same. From the first constitution to the present bylaws, the words "promote the game of golf" sum up a lasting objective of the Georgia State Golf Association.

The game itself in some ways is identical to how it was played in the 1890s. Nothing inspires excitement in golf like a well-hit shot. The most thrilling moment in golf is still the "eureka" moment when the golf ball obeys the golfer, whether in the form of a drive that lands in the fairway, an approach shot that stops on the green near the hole or a putt that drops into the cup.

ACKNOWLEDGEMENTS

Many people contributed to this book, and I am appreciative of everyone's assistance. Mike Waldron and Bill Blalock suggested that the GSGA have a book to celebrate its 100th anniversary, so they deserve credit for being the inspiration for this work. Martha Kirouac, while executive director of the GSGA, approved the project with the support of the executive committee. Belinda Marsh provided useful information on the GWGA. Mike Waldron, Gene McClure, Dave Ballard, Stan Awtrey, Linda Sommers, Layne Williams, Tripp Pendergast, Jeff Fages, Jerri Smith and Matt Williams provided information about the history of golf in Georgia and the GSGA. Dick McDonough, the author of *Great Golf Collections of the World*, provided the historic postcards of Georgia clubs from the early years of golf in Georgia. Warren Grant allowed us to use several of his fine photos of Georgia's golf courses, as did Shannon Bower, who also assisted with the photo research for the book. Jason Taylor of the GSGA staff assisted with photos from the collection of the Georgia Golf Hall of Fame. Augusta National Golf Club allowed use of one of its photos. At The History Press, Alyssa Pierce developed the project, which was then ably managed by Chad Rhoad; Jaime Muehl copyedited the text; and Anna Burrous contributed to the design. Lastly, Jim Ingram, with whom I shared many enjoyable rounds of golf, more than twenty years ago suggested that we attend the annual meeting of the Georgia State Golf Association, after which we both became volunteers. It has been a privilege being a part of an organization that benefits from efficient staff and dedicated volunteers.

PHOTO CREDITS

Wayne Aaron: p. 9

Atlanta Athletic Club: pp. 32, 43, 79, 86 right, 86 bottom left

Atlanta History Center: pp. 12, 14, 27, 35, 46, 50, 51, 100

Augusta National Golf Club: pp. 38, 108 right

Kate Awtrey: p. 99 right

Shannon Bower: pp. 17, 90 left, 92

John Companiotte: pp. 52, 61 color, 108 left, 109

Bob Cup: pp. 1, 82

Donald Ross Society: p. 34

Georgia Golf Hall of Fame: pp. 25 b&w, 40, 48, 49 b&w, 57, 58, 61 b&w, 63 b&w, 73

Warren Grant: pp. 15, 22, 54, 68, 71, 80, 88, 93, 98, 104

GSGA: pp. 42, 56, 60, 63 color, 65, 74, 76, 77, 83, 84 left, 85, 86 top left, 90 right, 91, 102, 106 top, 109, 110, 111, 115

Margie Hodges: pp. 26, 64

Jekyll Island Museum Archives: p. 11

Russell Kirk: pp. 19, 101, 107 left

Marcus Krause: 84 right

Lakeview Course: p. 62

Rob Matre: pp. 106 bottom, 107 right

Sid Matthew: p. 24

Dick McDonough: pp. 8, 10, 13, 18, 25 color, 31, 36, 45, 49 text box

Ed C. Thompson: p. 99 left

University of Georgia: p. 72

USGA: p. 41

ABOUT THE AUTHOR

John Companiotte is the author of six books on golf, including *Byron Nelson: The Most Remarkable Year in the History of Golf*; *Jimmy Demaret: The Swing's The Thing*; *Golf Rules and Etiquette Simplified*; and *The PGA Championship: The Season's Final Major*, written with co-author Catherine Lewis. He has been a volunteer with the Georgia State Golf Association for more than twenty years.